CONTENTS

Nature, when she invented, manufactured, and patented her authors, contrived to make critics out of the chips that were left.

Oliver Wendall Holmes
The Professor at the Breakfast Table, 1872

PREFACE

The idea for this book was conceived several years ago when Prentice Hall and I began to receive good reports on the criticism chapters in *Varieties of Visual Experience*. Norwell (Bud) Therien, Prentice Hall's art and music publisher, thought a short publication specifically devoted to art criticism might satisfy a growing need among lay people, artists, art instructors and their students. I agreed, and this little book is the result.

When writing a book—even a small one—the debt to one's teachers is always great. Let me mention some of mine in key disciplines: in studio criticism, my earliest teacher was Van Dearing Perrine; in drawing, John R. Grabach; in painting, Emile Alexay; in aesthetics, Abraham Kaplan; in art history, Karl With; and in iconography, Stanton MacDonald Wright. Let me also thank the "teachers" encountered mainly through the printed page: Erwin Panofsky, Herbert Read, Lionello Venturi, René Huyghe, Rudolph Arnheim, Meyer Schapiro, Arnold Hauser, Lewis Mumford, Stephen Pepper, Vincent Scully, Mary Matthews Gedo, and Kenneth Clark. To these

distinguished scholars and thinkers I owe an immense intellectual debt.

In a special sense, my teachers were students: they tolerated my monologues and added spice to our critical dialogue. That was fun. Without them the strategies advocated in this book could not have been tried out, and I would not have known what flies and what falls flat. But since these students number in the thousands, I must thank them collectively—at least for the ideas that work.

Finally, I am glad to acknowledge the help of the good folk at Prentice Hall who have played roles in the development, editing, and production of this book: Bud Therien, Lee Mamunes, Kerry Reardon, David Tay, and Kathryn Beck. And I am especially grateful to Virginia Seaquist who has been indispensable in performing the many tasks connected with preparing this manuscript.

Edmund B. Feldman

Other Books by Edmund Feldman:

Varieties of Visual Experience
The Artist
Thinking About Art

INTRODUCTION

The epigraph by Oliver Wendell Holmes gives us a good idea of the general opinion of critics more than a century ago. Whether just or not, it probably holds true today: art critics are not very highly esteemed. However, the purpose of this book is not to rehabilitate the reputation of critics; its goal is to improve the *practice* of art criticism. If that leads to a higher opinion of critics, so much the better.

The word "practical" in the title should alert readers to what this book is not. It is not an anthology of aesthetics or critical theory; it is not a compendium of critical writing; it is not a substitute for the history or philosophy of art. Having said this, let me stress my conviction that a command of "practical" art criticism is useful—indeed essential—for students and workers in all art disciplines.

Of course, critical theory creeps into the text. We cannot *do* criticism except in the light of some general ideas about what criticism is and what it ought to accomplish. The section in Chapter One dealing with "Critical Schools" offers a sampling of the diversity of current theories, together with some hints about their usefulness when it

comes to critical *praxis*. In most of the book, however, I touch on theory only when it seems necessary to justify certain critical *procedures*. For those who wish to delve into theoretical depth, there are a number of sources to consult in the references section of each chapter.

Ultimately, aestheticians and philosophers (not to mention ordinary citizens) must confront works of art and determine what they mean, whether they are any good, and, if so, why. I believe this is the point where practical criticism demonstrates its worth. Regardless of what you know about Santayana's "sense" of beauty or Danto's conception of an "artworld," there is no escaping the necessity of looking at specific artworks, discovering what they have to "say," and persuading the public that they really say what you claim they say. When you can do that, you have performed a valuable service for yourself and for legions of philosophers, critics, and metacritics. Someone, after all, must tell them what they are looking at. As we shall see, that is easier said than done, but it is worth trying.

Following is a short summary of the contents of this book. Chapter One defines criticism, followed by an overview of the purposes of criticism, the "schools" of criticism, and the ethical standards critics ought to observe. Chapter Two presents a sequential process for *doing* criticism, supplemented by definitions of terms, word lists, useful questions for critics to ask, and ways to judge individual critiques. Chapter Three focuses on the central task of criticism: interpretation. It offers some thoughts about the function of words in art criticism, the many kinds of visual meaning, and the various forms of explanation a critic can use. Chapter Four applies the concepts and methods in the earlier chapters to several issues currently agitating the art world: quality, censorship, pornography, and multiculturalism. These are only exemplar issues, but they are examined from what I believe is the distinctive viewpoint of art criticism.

Finally, the illustrations. I wish there were more of them to flesh out the words in the text. When it comes to books, literary critics have all the advantages: their texts *and* illustrations are verbal. But I have found a few visual images that may stick in your memory when the words are forgotten. If they encourage you to look at more works of art, and if you learn to see them more critically, then this prose of mine shall not have been in vain.

THE CRITIC

WHAT CRITICISM IS

Criticism is spoken or written "talk" about art. Almost everyone does it, so criticism is very influential. That is, it affects what artists make, what the public sees, and what collectors buy. Most artists have mixed feelings about critics, but they know that criticism—whether good or bad—can have a very long life. In other words, it can greatly influence their careers. As for nonartists, they are interested in criticism as well—if only because they wonder whether their opinions and preferences are shared. Thus, criticism has *power*. That is why we want it to be wise and thorough and fair.

Apart from affecting artistic reputations, why does criticism have power? The reason is that art is about many things besides drawing, painting, and sculpture. Although critics begin their work by talking about art, their talk soon moves beyond art. That is, to be critics, they must deal with the feelings, ideas, and events represented or symbolized in drawings, paintings, and sculpture. In a sense, critics are inter-

1

mediaries between works of art and the values or interests that art-works designate. So, while art has power in itself, the power of *talk about art* should not be underestimated.

We might say that a critic has two agendas. The first agenda is fairly specific: to comment on the aesthetic organization and technical execution of works of art. The second agenda is more general: to comment on the interests and values symbolized or expressed in works of art. Thus, a landscape painting may represent an opportunity to discuss the spectacle of nature, farming as a way of life, the transformation of the environment by human settlement, or the industrial pollution of the earth. This is not because critics care more about ecology than the problems of pictorial design. It is because landscape imagery inevitable speaks about ecological problems, and critics must go where the imagery leads.

In newspapers and magazines, art, music, literature, and film critics tend to be grouped in the back section, in the "cultural affairs" ghetto. That means they report on, or keep track of, the creative production of living writers, composers, musicians, painters, and film-makers. In a deeper sense, however, these "arts" writers comment on the direction of our culture as a whole. Their art criticism is more than a running report on certain reputations; it is a kind of collective commentary about the hopes, wishes, and fears expressed in the work of the "talented" few who are determined to paint or perform in public. It is from critical commentary on the work of these artists that we get many of our ideas about who we are, where we have been, and where we are going.

Full-fledged critics (as opposed to reviewers) have to deal with what is meaningful or trivial, original or trite, in the art they talk about. This entails more than the expression of personal preferences: it means that critics must discuss what is valuable—not only in art but in life, not only for the critic but for everyone. Well, how does a critic dare to talk "for everyone"? That question will be discussed below. Here, it is enough to say that in the field of art criticism, it is not possible to escape a value system—our own or a value system we have taken for our own. The important thing is to know what our values are.

In the end (but not in the beginning), criticism is coded talk about the ideas that artists have somehow communicated through their work. What makes critics great is their ability to see the needs and interests of the public expressed in an artist's work. Notice "interests of the public" and "an artist's work." These phrases point to a

unique function of criticism: to find significant connections between what an artist creates, what viewers care about, and what a critic *thinks* they should care about.

In discussing what viewers care about, critics have no license to philosophize freely; their commentary has to be based on what can reasonably be inferred from the art they and the public see. Artists are different: when they express themselves they may or may not consider the needs of viewers; they have a "poetic" right to focus on their personal experience. But critics do not enjoy that luxury; theirs is the business of making public sense out of art, whether it is good or bad, sophisticated or naive, meaningful or incomprehensible. Thus, criticism is an art, too. And, like any art, it can be done badly or well.

KINDS OF CRITICS

If criticism is talk about art, who does the talking? In a sense, everyone does. However, we can be more specific if we classify critics according to their occupations, social functions, and aesthetic interests.

The best-known kind of criticism is created by journalists. They range from lowly reporters to art reviewers to specialized art critics to cultural affairs editors. Some of them cover the entire art scene while others cover only certain art forms—architecture or photography, for example. The term "cover" is significant because it points to the unique character of journalistic criticism: it deals with art as a category of news. Journalistic critics are first of all reporters; hence art, artists, and the art world interest them mainly to the extent that they are newsworthy.

What makes art and artists "newsworthy"? Much depends on whether the news appears in a tabloid, a local journal, a national newspaper, a weekly newsmagazine, or a specialized art monthly. As we climb the scale of journalistic expertise, we encounter increasingly knowledgeable reporting, more critical analysis, and far more pictures. Someone has said that the purpose of written criticism is to fill the space between the pictures. Happily, the major journals employ trained art critics, they allot more room to criticism, they often have sophisticated readers, and they tend to be independent in their judgments.

Most journalists, however, do not make independent judgments: they lack the necessary experience, they do not have sufficient space, and their training emphasizes "human interest" stories more than aesthetic analysis. Therefore, what we usually expect from art journalism

is accuracy about the who, what, where, and when of art-world activity; the "why" tends to get lost. That isn't necessarily bad: in providing basic information, journalistic critics help create the public for art. Beyond that, they confirm the existence of an art world, they generate controversy about art issues (which builds readership), and they disseminate the notion that art experiences are worth having.

"Flackery," or press agentry, is not unknown in journalistic art criticism. It thrives for several reasons: readers of art news may be vulnerable because they lack background knowledge; or they know nothing of the intrigues that abound in the art world; or they are innocent of the commercial forces that drive the art market. Especially important is the fact that most people do not *see* the art being publicized; they only read about it. For this condition, there are several antidotes: we should read many critics, we should visit the great museums again and again, and we should *see* the artworks we have read about. Better yet, we should *see* the art first, decide whether it is any good, and read the flackery afterward.

Teachers of art make up another category of critics. Here we include teachers at all levels, teachers in every kind of institution, and teachers of art history and theory as well as studio subjects. This all-inclusiveness is based on the fact that *talk about art,* especially systematic talk about art, constitutes the substance of art criticism. Clearly, anyone who talks to students about the art they are making, the art they have made, or the art others have made, is acting like a critic.

Teachers of studio art function as critics in a special way: they *assign* art problems and exercises and they evaluate artwork when it is finished. Stated otherwise, they judge student work *as* it is made and *after* it is done. In effect, they criticize what they have caused to be created. This makes the studio critic a partner, or an accomplice, in the creative act and its outcome. Temporarily, at least, there is a merger of the student's identity with the teacher's identity. In studio criticism, this merger or combination of artistic personalities is exposed, so to speak. Whatever the teacher-critic says or does is fraught with significance; hence the process of teaching art requires the exercise of the utmost sensitivity and judgment.

In sum, all criticism has a pedagogical function, whether it is criticism for the general public, criticism for art collectors, criticism for aspiring artists, or criticism for school pupils. In each case, the critic advances ideas that guide viewers in their interactions with art. Instruction in artistic technique, even at the most rudimentary level, involves teaching students how forms and shapes express feelings and

ALBERTO GIACOMETTI, *Reclining Woman Who Dreams*, 1929. Bronze painted white, 9 1/2" x 16 1/2" x 5". The Hirshhorn Museum & Sculpture Garden, Smithsonian Institution, Washington, D.C. Gift of Joseph H. Hirshhorn, 1966. Photographed by Lee Stalsworth.

Finding meaning *in the artist's work* is the critic's principal quest. This means asking the right questions. Where is Giacometti's woman? Why does her head look like a spoon? What are those poles supposed to be? Has the woman become a skeleton? Is she in bed or in a cage? Is she floating? If so, is she floating in water or in space? Finally, what is she dreaming about?

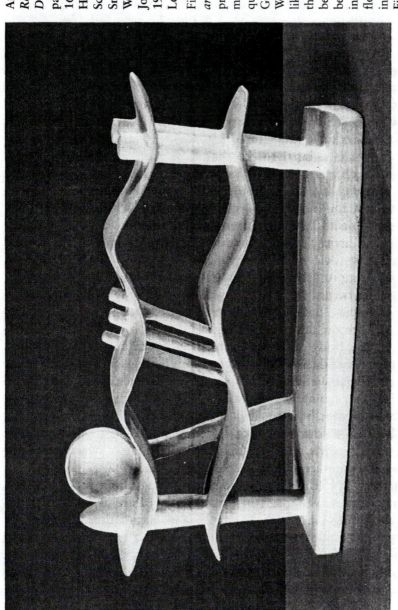

ideas; the disciplines of art history and aesthetics build on and profit from this teaching. After all, understanding the language of art does not occur spontaneously. It requires art instruction, which involves finding out how visual forms convey meaning, and what those meanings are. Thus, whoever teaches us to *see* meaning—in forms made by human hands, in the built environment, and in the natural world—is necessarily a critic.

Art scholars such as college and university professors, museum curators, art researchers, and authors of art texts are also art critics. That is, apart from teaching art or art history, they write the books and articles that eventually filter into the public consciousness as "standard" or "canonical" ideas about art and artists.

How does scholarly criticism differ from journalistic criticism? First, art scholars have more time to research a subject before writing about it. Journalists, on the other hand, live and work by deadlines. Time for research translates into time to reflect; and time to reflect plus scholarly training leads, or should lead, to well-seasoned judgment, which is to say, the judgment of history. Second, scholars know more about their subject. They are often specialists in a style, a period, a medium, or an artist. Third, scholars usually enjoy institutional sponsorship—that is, their work is subsidized by a university, a museum, a foundation, or a publisher. Such institutional sponsorship—theoretically, at least—protects scholar-critics from "outside" influences that might destroy their judicial detachment. (In connection with "judicial detachment," see the discussion of critical ethics on pp. 18–20.)

The largest body of critics is made up of lay critics. Indeed, they are so numerous and their opinions are so well known (once they were *our* opinions) that we tend to ignore their existence. However, popular criticism is extremely important. Why? Because it shapes what many artists create; because it is highly consistent and exceedingly durable; because it forms the established feelings and thinking *against which* the avant-garde rebels; and because, no matter what the avant-garde says, the people aren't fools all of the time.

Generally, lay critics know little or nothing about theory. Better, stated, they often have an unconscious theory of art, which is that art ought to be representational. Does this mean that the possession of normal eyesight equips a person to practice art criticism? Perhaps this suggestion is not as naive as it seems. "Normal eyesight" refers to the lay person's capacity for experience, ability to see the world truly, ability to understand what is happening, and desire to see the

acknowledgment of his or her existence in the world he or she happens to live in.

Lay or popular criticism is influential in the long run, but in the short run it tends to be ignored. Why? Because lay people don't have much money; that is, their pocketbooks often permit them to buy only inexpensive or "kitschy" art. And, they often admire and buy unfashionable art; popular criticism may aid and abet this behavior—therefore, it seems to be backward or *retardataire*. Yet popular or lay criticism tends to prevail over time. That is, after the excitement of the moment is over, popular taste is rediscovered by avant-garde critics who conclude that it was wise, even prescient. Thus, artists who want to create for the ages cannot afford to disregard the criticism of lay people: their vision is not always defective, and their aesthetic instincts are not always wrong. Besides, their sense of the real is what artists have to work with.

WHO NEEDS CRITICISM?

One of the functions of criticism is to create an appetite for art among those who didn't realize they were hungry. However, there are many people in whom that appetite is already strong. Who are they?

First, as suggested above, there are artists and art students. Artists, especially, are readers of criticism, even if they deny it. Why? The answer is that it affects their careers, it lets them know when they have "connected," it gives them feedback, and it tells them whether they are loved.

More seriously, artists care about criticism because it can clarify what they have said in another language. Especially satisfying to artists is the experience of seeing the completion of a "dialogue" that began in the studio when no one else was present. In setting goals, in perfecting a style, in deciding on a new creative direction, every artist needs the response of at least *one other* discerning person. For art students, that person is usually a teacher or a fellow art student. For professional artists, an honest critic is hard to find; friends and relatives will not necessarily do. So, artists need discerning critics—experienced professionals who can look at their work and tell them what they are doing and whether it really matters.

The artist's need for criticism was well expressed by the British art historian and museum director, Michael Levey: "The point is that

even the greatest artists of the past were once young and unproved: they were not *born* historically important. People once risked judgments about their work."[1]

In addition to artists, dealers care about criticism. Indeed, some have been known to *employ* critics. The awkward subject of critical conflict of interest leads an experienced observer of the "scene" to make this statement: "Currently, art writing is more often than not paid publicity...and exhibition 'curators' are just as often press agents and commissioned sales people."[2] Our critical ethics (p. 18) goes precisely to this point. With artists in the stable, with money tied up in art inventories, with the cost of light, heat, and rent, and with mounting exhibition and advertising expenses, art dealers have an urgent interest in criticism: it enables them to sell.

One of the dealer's chief purposes is to build a market for his or her artists. There are many creative ways to "build a market," and the ability to promote favorable comment is one of them. Ideally, good art will attract favorable attention, but as knowledgeable folk know, favorable attention is also the product of a favorable *climate of criticism* for a certain style, that is, for artists working in a certain style. Hence dealers care about the commentary—from word of mouth to obscure news items to good reviews to "think-pieces" in prominent art journals. All of this helps build a "favorable climate of criticism"—a climate which, it is hoped, will create a market for the artists a dealer happens to represent.

If good critical commentary is not forthcoming, bad commentary may do just as well. As many artists have learned, publicity helps build a career, and art criticism—for better or worse—belongs to the apparatus of publicity. For dealers, then, art criticism serves the following purposes: it alerts them to the arrival of fresh talent, it enhances the value of works they possess, it generates excitement about the artists they represent, and it creates a dignified form of communication with the art-buying public.

Collectors are another group with a strong interest in criticism. To be sure, their motives vary—some care mainly about the monetary value of their collections; others love the artworks they have acquired and want the public to love them too. Still others admire certain artists and want them to prosper. A more subtle motive of some col-

[1] Michael Levey, "Putting the Art back into Art History," *Leonardo,* vol. 9 (London: Pergamon Press, 1976), p. 64.

[2] Barbara Rose, "Tabula Rasa," *The Journal of Art,* vol. 1, no. 1, November 1988.

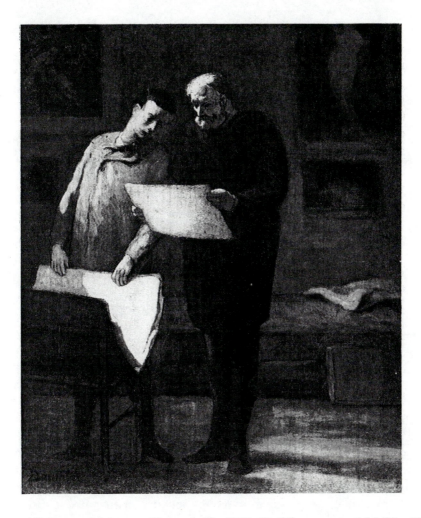

HONORÉ DAUMIER, **Advice to a Young Artist, 1855–60. Oil on canvas, 16 1/8" x 12 7/8". National Gallery of Art, Washington, D.C. Gift of Duncan Phillips.**

Artists don't always want advice—especially from critics—but there are times when it helps. Here Daumier portrays a critic in a warm and friendly light. If he is a good critic, he can give the artist what he desperately needs: an honest response, a truthful account of how the work affects at least *one other* human being.

lectors is the desire to see their aesthetic judgments vindicated—not so much by the art market as by the opinions of those who are truly knowledgeable.

We can set the aesthetic and psychological motives of collectors above their merely pecuniary concerns. For very wealthy persons especially, monetary values do not have much meaning. Still, it is gratifying to know that their aesthetic preferences, their critical judgments, and their cultural perspectives have been confirmed by the

opinions of experts. Indeed, it is pleasing for a rich man to know that he is good at something beyond making money. The great connoisseur of Dutch art, Max Friedlander, spoke of a collector who "had learned from the Rothschilds that the only respectable way to show increasing wealth was in the form of precious works of art."[3] Earning the respect of collectors and connoisseurs, recognizing excellence before anyone else, distinguishing between trendiness and quality, demonstrating prowess in the art market: these are attractive goals to high-status individuals, and art criticism helps them measure progress toward their goals.

Museum officials also have an interest in criticism. Their directors and curators make art purchases, or they recommend purchases to trustees and acquisition committees. These recommendations must be fortified by something more than a director's opinion, because an institution, especially a public one, cannot make one person *solely* responsible for spending large sums of money. To avoid placing sole responsibility for art purchases on museum directors or foundation officers, acquisition committees are useful in diffusing the risks of judging.

What do committees do in the course of making their collective judgments about the worthiness of artists for support or the eligibility of artworks for purchase? They make visits to the field, they confer, and they collect information from panels of experts or referees. Here art criticism is important, for, employed in this way, criticism is a major type of "disinterested" information. Why is this so? Because art critics operate at "arm's length" from cultural institutions, because criticism can be persuasive in itself, because criticism constitutes the substance of an artist's reputation, and because it is easier to judge a critic than to judge the art itself! Finally, art criticism can be useful to a museum or a foundation when an award or a purchase falls short of expectations. At least, in such cases, there was a collective judgment, based on independent criticism, that prompted the award or purchase.

Notice that in discussing the individuals, groups, and institutions that care about criticism, we seem to describe a simmering stew, a stew whose separate ingredients are responsible for the making, buying, selling, collecting, and preserving of works of art. But what makes these varied ingredients taste good? It is the gravy, which is to say, art criticism. It is criticism what makes the stew interesting; it is criticism that makes the art system work.

[3] Max Friedlander, *Reminiscences and Reflections* (Greenwich, Conn.: New York Graphic Society, 1969), p. 104.

THE CRITIC'S PURPOSES

The first purpose of a critic is to *understand* specific works of art. The other purposes—which are worthy for many reasons—follow from this first purpose. Critics cannot function on behalf of art, artists, and society if they cannot, first of all, understand works of art on an individual basis. The trouble with Harold Rosenberg's criticism, according to John Russell, was that "he was not a man who could focus on a single canvas."[4] The edifices of art history, aesthetics, and philosophy of art are built on this foundation; their lofty generalizations rest on critical bricks and mortar. Indeed, there is little we can legitimately say about art which does not depend on our own, or someone's critical understanding.

The second purpose of a critic is *explanation*. No doubt there are people who worship art, love art, or feel it in their bones. Critics, however, have an obligation to explain art—that is, their role is to communicate meaning. Now philosophers write books on the theory of explanation, but for the purposes of practical criticism, we need a definition that is succinct and operational. Accordingly, we may say that a critic's explanation should make the meaning of an artwork understandable *to a particular public*. In order to accomplish this purpose, a critic must *understand* his or her "particular public." In fact, critical explanation builds on two kinds of understanding: the first results from a meaningful encounter with an artwork, and the second results from assessing the needs and interests of the people he or she works for.

A third critical purpose is public *guidance* In other words, critics are employed to advise the public about what to see, what to admire, what to avoid, what to prefer, and what to support in the realm of art. We may not want guidance, we may not need guidance, or we may not like the guidance of a particular critic. Nevertheless, the public expects a critic to "stand for" something; it expects guidance from a critic while feeling free to reject it. The special virtue of critical guidance is that it isn't compulsory: it is effective only when it is persuasive.

A fourth critical purpose is to *establish standards* of excellence in art and art criticism. Most of us agree that critics should strive for excellence—that is, they should be guided by standards based on the work of the best critics. However, the idea of *artistic* standards of excellence, or quality, is currently under fire, largely because such standards vary according to time, place, and culture. This argument— the argument of cultural relativism—has some validity from an

[4] John Russell, "The Action Critic," *The New York Times*, April 22, 1979.

anthropological standpoint. However, every art critic belongs to a particular age, place, and culture; to function effectively critics cannot abandon their values. Nor does the public expect them to abandon their values, their distinctive points of view. Like all of us, critics see the world through cultural lenses; those lenses need not be broken, but critics must see through them clearly. That is the way excellence is perceived, and that is how standards are improved.

A fifth critical purpose is the *clarification* of aesthetic and cultural issues. Perhaps philosophers of art should do this work, but few of us read their journals. Besides, the public wants aesthetic questions to be argued in connection with works currently on view, currently being celebrated, or currently being attacked. Consequently, we look to critics to define the terms, sort out the issues, and produce the appropriate evidence for discussing our differences in taste, judgment, and cultural policy. If critics cannot bring peace, at least they can bring sanity to our cultural wars.

The foregoing list of critical purposes may be incomplete. Others might add public education, art advocacy, and the elevation or refinement of popular taste. Still others would like critics to be aesthetic watchdogs, capable of recognizing artistic fraud and ready to bark when our temples of high art are invaded by trash. But here our third purpose, public guidance, describes the critic's appropriate role.

Finally, shouldn't the enhancement of pleasure be one of the critic's purposes? Surely art gives pleasure, but the question is whether art *criticism* gives pleasure. Perhaps not in itself—although the criticism of Kenneth Clark gives me pleasure. Consider his eloquent description of the civilians about to be shot in Goya's *Third of May*: "But the victims of power are not abstract. They are as shapeless and pathetic as old sacks; they are huddled together like animals...in the middle a man with a dark face throws up his arms, so that his death is a sort of crucifixion. His white shirt, laid open to the rifles, is like a flash of inspiration which has ignited the whole design."[5]

Critics do add to the sum of our pleasures, they can increase the intensity and duration of our pleasures, and they often introduce to "higher" pleasures, no matter how these are defined. I think the accomplishment of the critic's purposes depends very much on the *quality* of a critic's work, which is why criticism is an art. When a critic is successful in this "art," all of us benefit. And when a critic does not succeed, we usually learn something from the effort.

[5] Kenneth, Clark, *The Romantic Rebellion* (New York: Harper & Row, 1973) p. 88.

THE CRITIC'S AUTHORITY

What makes someone a critic? Who anoints her or him? Artists certainly ask these questions, especially if they have suffered some critical cuts and bruises. We might answer that art critics—like politicians and presidential candidates—frequently nominate themselves. They are self-anointed, so to speak, which means that critics usually have a great deal of confidence—or nerve. In any case, there are formal requirements for becoming a critic, beyond feeling "called" to tell the world what one thinks.

Obviously, *formal education* is a prime requirement. We expect a critic to know a great deal about art. And, in addition to knowledge of art, there should be knowledge of the art of criticizing art. Where or how does one gain that knowledge? One gains it from reading, from travel, from the experience of making art, from the study of art history, and from watching good and bad artists at work. This latter source of critical wisdom should not be disdained. Observation of art-making processes yields valuable insight into the behavior that produces what we see.

Beyond education, travel, studio experience, the study of art history, and observation of art-in-the-making, what else confers critical authority? *The ability to communicate clearly, logically, and persuasively.* Critics are supposed *to share* their insights, justify their opinions, and convince their publics. The fact that one enjoys or heartily dislikes an artwork has very little critical value: one must be able to explain an interpretation and give reasons for a judgment. Eloquence and rhetorical skill are good things for a critic to have, but even more important—given the incoherence of so much criticism—is clarity of thought and expression.

What has been said so far can be summarized as follows: we want a critic to be knowledgeable, intelligent, and reasonably skillful as a writer or speaker. Another important source of critical authority might be called *judicious temperament.* That is, a critic should be the sort of person who prefers to gather information, suspend bias, and weigh the relevant facts before issuing an opinion. Many of us are not made that way, so we must learn the following critical principle: never "shoot from the hip."

Breadth of sensibility is another essential attribute of an art critic. It means that a critic should be open—emotionally and intellectually— to a wide range of artistic styles, media, themes, and techniques. Remember that a critic serves a public and that public is not well

served if the critic is restricted in his or her range of emotion or toler-
ance of subject matter. A critic has a professional obligation to deal
justly with many kinds of art, including the kinds he or she doesn't
like. Disliking a certain kind of art is no excuse for failing to under-
stand its meaning. Why? The answer is that we cannot judge a work
of art if we do not know what it is trying to say.

There is one thing we know about the judicial process in a court
of law: it takes time. In art criticism, too, time is an important factor.
Like a judge, an art critic is under continuous barrage from the testi-
mony of witnesses, and the arguments of lawyers, and the work itself.
That is, a work of art often represents a skillful assault on a critic's
sensibility. The language of visual form is calculated to reach very
deep levels of awareness; often it makes a deliberate appeal to the irra-
tional qualities in our nature. Now the critic's function is not to resist
that appeal, but to feel it, question it, and reflect upon it. Yet, reflec-
tion takes time and the right mental equipment. An art critic, like a
judge, has to give his or her equipment a chance to function.

A final and vitally important aspect of a critic's equipment is
self-knowledge. For practical purposes, this means we must know
what we do not like, what we cannot feel, and what we see with diffi-
culty. A critic must know when a work of art speaks about experi-
ences he or she has not had, emotions he or she has repressed, and
ideas he or she will not accept. Curiously, this knowledge—which is
essentially about our limitations and shortcomings—becomes a criti-
cal asset; it calls attention to the special quality or appeal of a work
of art. It works by indirection; it reminds us of a logic that human
beings (as opposed to computers) employ in solving problems. For
example, we get good answers by eliminating bad answers; we identi-
fy a thing by what it is not; and we seek clues to meaning or value in
places we normally overlook. In other words, we know what we
don't know, and that knowledge—essentially self-knowledge—makes
for a better critic.

CRITICAL SCHOOLS

Schools and fashions in criticism abound—sometimes in response to
new kinds of art, sometimes in the hope of finding new meaning in
established art forms. Most critical approaches originate in literary
criticism, although some come out of philosophy, anthropology,
media studies, and information theory. For practical art criticism, the

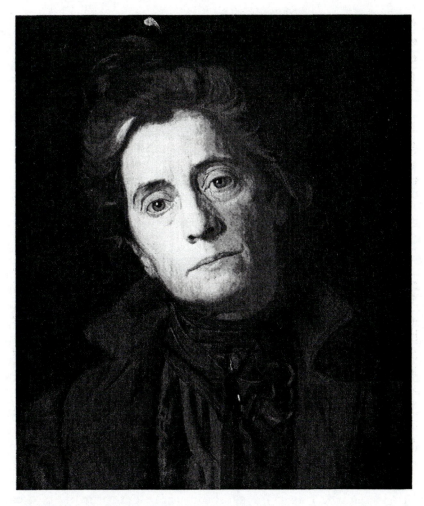

THOMAS EAKINS, *Mrs. Thomas Eakins.* c. 1899. Oil on canvas, 20" x 16". The Hirshhorn Museum & Sculpture Garden, Smithsonian Institution, Washington, D.C. Gift of Joseph H. Hirshhorn, 1966. Photographed by Lee Stalsworth.

Often, the critic works with what the image could have been, but is not. Eakins' wife could have been made younger, prettier, happier, and more fashionable. Instead, she is shown to possess other, more durable, qualities. The critic's task here is to find meaning in the contrast between conventional expectations and what is actually there.

"schools" vary in their usefulness. Some are relevant only to literature; some ignore matters of techniques; some are confined to questions of judgment; some are general theories of art rather than art criticism; some substitute the critic's imagination for the artist's production; and some are extensions of the critic's political or psychological predilec-

tions. Nevertheless, art critics should be open to their hermeneutical—that is, their interpretive—potential. Following is a list of the chief critical approaches with a brief description of their characteristic aims or methods.

Contextualism. This may be the principal method of art-historical explanation. The work of art is understood as the product of a distinctive mixture of factors—religious, philosophical, political, and economic—which predominate in a certain period or place. But even when it is enlightening, contextual method is prone to circular reasoning (classical art is created by classical artists during periods when classicism flourishes), and it can underrate the importance of an individual artist's creativity.

Marxism. Here art is an expression of the class struggle—that is, the continuous war in society over control of the material means of production. Vulgar Marxist criticism tends to reduce that struggle to a disclosure of the artist's or patron's class origin and economic interests. When it comes to judgments of quality, artworks are often valued according to their sympathy for the proletariat and hostility toward the bourgeoisie. A more sophisticated Marxist critic values the honest or "realistic" representation of social conditions. In Marxist theory, art form expresses ideology, which is a product of class structure, which is a mirror of the economic relations in society. This book treats Marxism as an "instrumentalist" ground of judgment (see. p. 40–41).

Freudianism and Psychoanalysis. In this approach, the artwork is regarded as (1) a symbolic representation of its creator's inner life; (2) a disguised representation of the artist's painful memories, unresolved conflicts, and repressed sexual desires; or (3) a metaphoric representation of society's fears and taboos. To be understood, artistic images have to be "unpacked" by the critic since, like dreams, they result from the *condensation* and *displacement* of real-life experiences.

Phenomenology. This is a powerful method of focusing the critic's perceptual powers on the actual features of an artwork. Through *epoché*—or "bracketing" or suspension—of preconceived notions, the phenomenological critic endeavors to experience the distinctively aesthetic (as opposed to literary, religious, and economic)

properties of the art object. Interpretation is the business of explaining, or making explicit, what has been phenomenologically perceived. As for judgment, it also takes place in the perceptual act.

Semiotics. This approach is really a theory of art, according to which artworks belong to "sign situations" that can be classified as pragmatic (useful), syntactic (formal), and semantic (meaningful). The semiotic critic focuses on the codes or conventions that govern the inherent meanings and cultural interpretations of artworks. There is some similarity here to the art historian's use of iconology to explain the meaning of visual symbols in distant cultures.

Feminism. In this approach, the work of art is explained in terms of its bearing on the status and changing roles of women, the interactions between art and gender, the exclusiveness or inclusiveness of the art-historical canon, the oppression or exploitation of women, the functions of patriarchy or matriarchy in an artist's expression, sexist representations of women, and the distinctive perceptions of women in various periods and cultures.

Structuralism. This is a linguistic theory that endeavors to explain what makes *art* meaningful, as opposed to what individual works of art mean. Structuralism seeks the laws that generate meaning in any form of communication. An exchange of goods, for example, is a form of communication and, hence, subject to critical interpretation. In general, structuralism constitutes a method of analyzing ideologies, cultures, and systems rather than specific artworks; its value is sociological and anthropological more than critical.

Deconstruction. This approach is a type of post-structuralism that is truly critical insofar as it reads or interprets *individual* artworks. The value of deconstruction lies in its openness to the disparate, frequently conflicting meanings within a single text or artwork. Deconstruction tends to be annoying because it is the critic, not the artist, who defines the work or text to be interpreted. Thus the meaning of the work changes according to the critic's needs, and no final or authoritative reading is possible.

Postmodernism. This is a style or an outlook more than a critical school. Postmodernism is almost impossible to define except as a

declaration of the end of modernism. As a visual phenomenon, its main trait appears to be play with forms, styles, and the processes of art-making. As a philosophic outlook, its principal theme is the *contingency* and *indeterminacy* of all meanings and structures. As a phase in the history of ideas, it strongly resembles post–World War II existentialism.

Having read this list, you may be inspired to remember the exclamation of Moliere's *Bourgeois Gentilhomme* after he hired a tutor: "Good Heavens! For more than forty years I have been speaking prose without knowing it." Similarly, you may have been practicing contextual or phenomenological or poststructural criticism. Now, perhaps, you realize what you were doing.

THE CRITIC'S ETHICS

Ethics is usually understood in a negative context, as in a list of "thou shalt nots." So, we shall begin by listing the things art critics ought to avoid. Then we shall conclude with *positive ethics,* expressed in a list of things critics should try to do, even if it is difficult, and even if they succeed only partially.

- Critics must avoid *conflict of interest.* That is, critics should not write about their own work, or the work of close relatives and dear friends. Does this mean critics should not marry artists, or have friends among artists? No, but they should disclose personal relationships that bear on their criticism .
- Critics should not use their commentary to damage the reputation of any person or group. A work of art may be offensive to a person or group, but the critic's commentary should not *gratuitously* add to the offense.
- When writing about an artist, a critic should have no pecuniary interest in the work of that artist. Does this mean critics should not own works of art? No, but a critic's commentary should not be calculated to increase the monetary value of his or her art collection.
- A critic should not work for, accept money from, or receive other gratuities from, art dealers or agents who handle the artists a critic writes about.
- A critic should not accept a work of art as a gift from an artist or a dealer, even if the gift is given innocently.

GEORGES BRAQUE, *Still Life: The Table*, 1928. Oil on canvas, 32" x 52 1/2". National Gallery of Art, Washington, D.C.

You have a right to know that I set social values above decorative values in art. Hence, I consider Picasso's *Guernica* "more important" than Braque's *Still Life*. Nevertheless, I have an obligation to criticize the Braque in terms of *its* goals: to challenge the assumptions of pictorial space; to play with the solidity and transparency of things; to question the reality or falsity of outlines; and to explore the interactions of colors, tones, and textures.

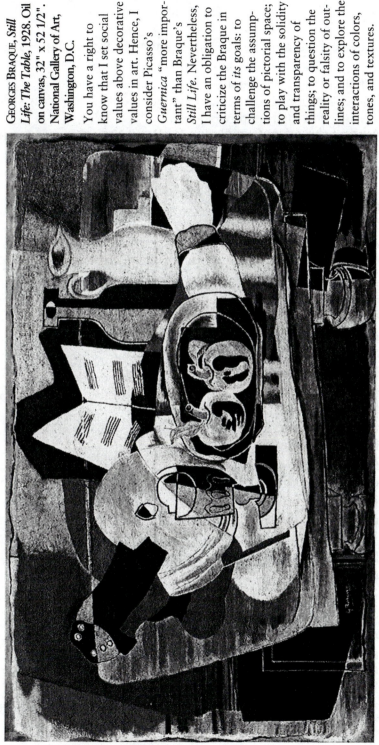

- A critic should not accept a commission or fee contingent on the sale of a work of art about which the critic has written favorably.
- When a critic receives a fee for an opinion about the provenance, quality, or monetary value of a work of art, that fact should be disclosed to interested persons.
- A critic should not knowingly misstate the facts about works of art—their dates, authorship, provenance, history of ownership, selling prices, and so on.
- A critic should not make a pact with fellow critics, gallery owners, or museum officials to promote the work of any artist or "school" of artists.
- A critic should not privately advise artists about their work and then publicly discuss the work created according to that advice.
- A critic's commentary should not indicate how *the critic* would have done the work. That is, critics should not "second-guess" artists.
- A critic, acting as art expert, should not advise both the seller and buyer of a work of art.
- Critics should not use their commentary to embarrass artists, to condemn their character, or to question their extra-artistic motives.
- Critics should not spread gossip about other critics or condemn their work on personal grounds.
- Critics should not give the interpretations of other critics as their own, except with proper attribution.
- A final admonition: critics should not obfuscate, mystify, judge rashly, or hide behind their learning.

Following is what might be termed positive ethics, a list of things critics *ought* to do.

- Critics have an obligation to inform themselves as well as they can about the facts—physical, technical, historical, and stylistic—pertaining to the artworks they discuss.
- Critics should report on works of art they have personally seen. Reproductions may be used as memory aids but not as substitutes for a direct encounter. Scholars may work with photographs, but critics must experience the original.

- A critic should judge the artistic result and the aesthetic effect, not the creative intention.
- A critic should disclose any political, ideological, or religious commitment or affiliation that might bias his or her commentary.
- In comparative or "judicial" criticism, a critic should relate the work of art to other works of similar purpose and effect.
- If a critic employs a priori standards in judging works of art, those standards ought to be made explicit "up front" or in the context of the appraisal.
- Critics should encounter every work with a "positive tilt." That is, they should be predisposed to discover value and merit in every work selected for commentary. This ethic follows the principle of "innocent until proved guilty."
- Notwithstanding their predispositions, critics should consider that they act first on behalf of the public and then on behalf of artists and the art world.
- Remember, too, that every artwork is in some sense a disclosure of the artist's self; hence, critical commentary should be honest without being hurtful.[6]
- When interpreting and judging works of art, critics should suppress what they know about the artist. That is, they should give visual evidence priority over documentary evidence and word-of-mouth reports.
- Final advice: when doing criticism, critics should be sure they are not sleepy, angry, hungry, running a low fever, anxious to be elsewhere, or expecting an important call. Stated more positively, a critic should *be ready for* an aesthetic occasion.

REFERENCES

Arnheim, Rudolf. "What is a Critic?" *Saturday Review,* August 28, 1965.

Burnham, Sophy. *The Art Crowd.* New York: McKay, 1973.

Cahn, Walter. *Masterpieces: Chapters in the History of an Idea.* Princeton, N.J.: Princeton University Press, 1979.

[6] Arnheim put this point well when he said: "A critic is not useful...when he despises rather than feels compassion for human incapacity." (Rudolph Arnheim, "What is a Critic?" *Saturday Review,* August 28, 1965, p. 26)

Clark, Kenneth. *Moments of Vision.* New York: Harper & Row, 1982.

_____ . *The Romantic Rebellion.* New York: Harper & Row, 1973.

Diamondstein, Barbaralee. *Inside New York's Art World.* New York: Rizzoli, 1979.

Feldman, Edmund B. *The Artist.* Englewood Cliffs, N.J.: Prentice-Hall, 1982.

_____ . *Varieties of Visual Experience,* 4th ed. Englewood Cliffs, N.J.: Prentice-Hall and Abrams, 1993.

Friedlander, Max. *Reminiscences and Reflections.* Greenwich, Conn.: New York Graphic Society, 1969.

Glueck, Grace. "Tastemakers," *New York Times Magazine,* August 30, 1987.

Grundberg, Andy. "Art Under Attack: Who Dares Say That It's No Good?" *New York Times,* November 25, 1990.

Guilbault, Serge. *How New York Stole the Idea of Modern Art.* Chicago: University of Chicago Press, 1983.

Hauser, Arnold. "Art Criticism." In Kenneth J. Northcott (ed.), *The Sociology of Art.* Chicago: University of Chicago Press, 1982.

Hughes, Robert. *Nothing If Not Critical.* New York: Knopf, 1991.

Jacobs, Jay. "What Should a Critic Be?" *Art in America,* No. 1, 1965.

Keen, Geraldine. *Money and Art: A Study Based on the Times-Sotheby Index.* New York: Putnam, 1971.

Levey, Michael. "Putting the Art Back into Art History," *Leonardo,* Vol. 9. London: Pergamon Press, 1976.

Lipman, Samuel. "Say No To Trash," *New York Times,* June 23, 1989.

Lynes, Russell. *The Tastemakers.* New York: Harper, 1955.

Naifeh, Steven W. *Culture Making: Money, Success, and the New York Art World.* Princeton, N.J.: Princeton University Press, 1976.

Rose, Barbara. "Tabula Rasa," *The Journal of Art,* vol. 1, no. 1, November 1988.

Rosenberg, Bernard, and Norris Fliegel. *The Vanguard Artist: Portrait and Self-Portrait.* Chicago: Quadrangle Books, 1965.

Russell, John. "The Action Critic," *The New York Times,* April 22, 1979.

Steinberg, Leo. *Other Criteria: Confrontations with Twentieth-Century Art.* New York: Oxford University Press, 1972.

Tompkins, Calvin. *Robert Rauschenberg and the Art World of Our Time.* New York: Doubleday, 1980.

Vogel, Carol. "Are they fake Warhols? Are they real Warhols? How real are real Warhols? How real was Warhol?" *New York Times,* July 17, 1992.

Wolf, Naomi. *The Beauty Myth.* New York: Morrow, 1991.

Wraight, Robert. *The Art Game Again!* London: Leslie Frewin, 1974.

THE CRITICAL PROCESS

ATTENDING TO VISUAL FACTS

Critics are often accused of being arbitrary and subjective—too imaginative for their own (or the artist's) good. To counter these accusations, we stipulate that a critic must attend, first of all, to the visual facts. Why is this important? It is important because a critic's interpretation should originate in what is objectively there, because fairness to the artist requires that we give highest priority to what he or she has made, and because anything a critic says should be based on what someone else can verify.

What are the visual facts? For the critic's purposes, they are the physical features of an artwork that another person can see. Thus, we can see faces, figures, trees, rocks, colors, shapes, and textures. But we cannot see linseed oil or molecules of paint even though we know they are there. For art criticism, the visual facts are the "gross," or perceptible, manifestations of an artwork. We know that the chemical analysis of a paint film and the geological analysis of marble fragments can

yield valuable information for archaeologists, connoisseurs, and restoration experts. However, the critical enterprise relies on the way the human organism processes information it has gained *through its own optical apparatus.* That is, we care mainly about the way artworks are seen with the naked human eye.

Another stipulation about the visual facts is that they should be given priority over words. Better stated, words about an artwork should be considered valid only to the extent that they can be confirmed in the critic's visual experience. This rule is important for two reasons: (1) it saves us from confusing discourse *about* art with art itself; and (2) it prevents us from claiming another person's experience as our own. Having said this, we must admit that spoken or written commentary is often useful: it can direct our attention to what might have been overlooked, it can tell us what someone else considers interesting, and it may contain hints about the overall meaning of a work of art. Our wariness about words does not mean we advocate literary ignorance; however, critics should use words as "pointers" rather than as aesthetic facts.

Clearly, we have a "hidden agenda" in attending to the visual facts. As mentioned earlier, seeing a work truly and well *takes time.* Not only that, it calls for considerable effort. In other words, we want to trick the critic into doing three things he or she might not have done: (1) we want the critic to *see* more than he or she might have seen, (2) we want the critic to *invest* more of himself or herself than he or she might have invested, and (3) we want the critic to *delay* the closure of his or her experience. That delay or *postponement of closure* will turn out to be beneficial because it creates time for several good things to happen: the critic begins to "see" really well, the critic's imagination comes into play, and the critic's "creative juices" are given a chance to flow.

A final point about attending to the visual facts should be noted. Many critical disasters are caused by (1) failing to see the work completely, and (2) premature closure of the critical process. Premature closure, in turn, leads to what I call "abortion" of the aesthetic experience; it is usually caused by the critic's impatience, prejudice, or unwillingness to suspend judgment. That is, the critic knows *in advance* that the work is bad or good and hence will not give it the benefit of a thorough examination. This is a common sin in criticism. To defend against this error, we have our critical discipline: attend to the facts, analyze the facts, interpret the facts, and judge the whole

work afterward. By following this sequence, a critic will avoid a great deal of embarrassment.

NAMING AND DESCRIBING THE FACTS

Art criticism begins with an information gathering stage; and, as indicated above, attending to the visual facts is its key feature. In the process, we also admit the sort of information one gets from museum labels—that is, the name of the artist; his or her country, perhaps; the medium and date of the work; and its title.

Now, titles are important in criticism; whole books could be written about them. For the purposes of practical criticism, let us say this: some title are obvious, some are vague and mysterious, some are purely literary exercises, some offer hints about subject matter, some describe technical objectives, some are unintentionally misleading, and some are calculated to throw us "off the scent." Our rule is as follows: when a title seems to make sense, use it to form an hypothesis (see pp. 32–35) about the meaning of the work. But if the title conflicts with the visual facts, do not use it.

Naming what an observer sees is part of the overall process of description. With realistic works of art, the task is easy enough: adults can do it almost as well as children! What we aim for is a list or inventory of the principal things that are *there*. And, we want that inventory to be noncontroversial, so we do not characterize the things we see (persons, places, and objects)—we just name them. That seems to make children very happy. Adults, however, want to tell us what they think or how they feel about what they see. *This must be discouraged.* At the naming stage of criticism, we should employ neutral, unloaded, value-free language.

When it comes to *describing* the things we see—especially in an abstract or nonobjective work—we simply fall back on the language of *line* (straight, curved, jagged, and so on), *shape* (square, triangular, and circular), *color* (red, blue, green, and so on), and *texture* (smooth, coarse, and grainy). Again, our language is unloaded, and, while we may have feelings about these "things," we try to suppress them. The critic's purpose here is to build an inventory that is reasonably complete and uncontaminated by moral, emotional, and cognitive associations. Thus, description—which is a fairly simple operation—has two sophisticated objectives: one is to *encounter* the surface of an artwork

honestly and without preconceptions, and the second is *to know* the work as immediately and directly as we can.

Naming and describing visual facts is an important operation because it *slows down* and *concentrates* the critic's perception. Lord Clark says "description has a further value, that it makes us look at a work of art far longer. 'We must look and look' said Mr. Berenson 'til we live in a painting and for a fleeting moment become identified with it.'"[1] Normal or everyday perception is usually very fast—fast enough to perform the tasks of practical life. Aesthetic perception, on the other hand, aims at the *intensification of vision,* by which we mean the fullest possible involvement of a critic's sensory and cognitive equipment. The process of describing encourages a critic to dwell or concentrate on the work of art; in John Dewey's words, it enables the critic to "have an experience."

We should realize, too, that describing visual facts does not mean translating lines, colors, and shapes into words. Of course, some writers and critics try to paint with words. But we know that words cannot be the optical equivalents of visual forms; words are used to name or identify the things we can see. Paradoxically, we employ verbal language to call attention to an artwork's *nonverbal* features—the visual qualities for which there are no words. In addition, verbal description gets the ball rolling, so to speak; it initiates a critical game whose goal is the defensible interpretation and evaluation of a work of art.

Description has another important function: it helps us to achieve critical consensus. Many controversies among critics are caused by the fact that they are working with *different sets of visual facts.* Of course, critics have a right to differ in their interpretations, but the public has a corresponding right to know whether the critics have seen the same work of art. Now, what is that "work of art?" It must be the set of facts the critics have named and described. But suppose the critics will not disclose the facts supporting their critiques? Then we have two options: one is to guess what they saw; the other is to find a better critic!

Notice, finally, that description in art criticism corresponds to decoding ciphers in cryptography, or sounding out letters and pronouncing words in reading. A reader may be able to say a word and may know what it means; however, that reader may not understand the overall significance of the word in the sentence where it appears. Decoding words in a sentence is not equivalent to *comprehension*—understanding the sentence as a whole. In English, at least, word

[1] Kenneth Clark, *Moments of Vision* (London: John Murray, 1981), p. 84.

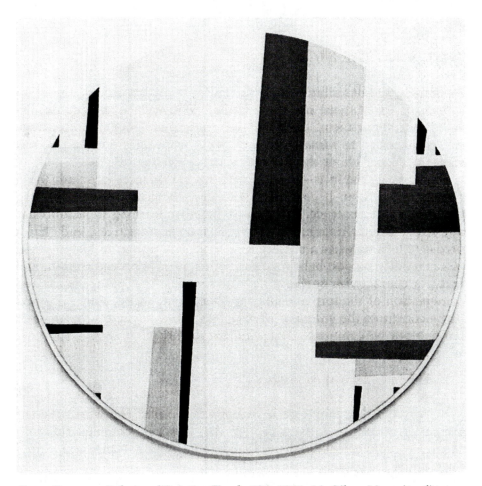

FRITZ GLARNER, *Relational Painting Tondo #20*, 1951–54. Oil on Masonite, diameter 47 3/8". The Hirshhorn Museum & Sculpture Garden, Smithsonian Institution, Washington, D.C. Gift of Joseph H. Hirshhorn, 1972. Photographed by Lee Stalsworth.

Without describing the forms and their action, we cannot understand their overall meaning. Notice, for example, the tapering shapes in this composition. Where do they begin and end? Do they just meet or do they pass beneath each other? Notice, too, that there seems to be some shifting and squeezing among the forms. Are they wedges? Why are the smaller ones located near the circle's edge? Is this work about splitting or weaving or fabrication? Is it a random assortment of forms about to settle into a system? Does it represent the outer edge of things? Maybe this is a picture of the place where chaos turns into order.

placement and sequence determine comprehensive meaning. And, the same is true of the lines, shapes, and colors in a work of art: location is crucial. In other words, art has a grammar and syntax which critics must be able to "read."

ANALYZING THE FACTS

By naming and describing what we can see in an artwork, we build up a body of visual facts; our hope is that there will be little or no disagreement about them. If we can get consensus about the facts, they can be regarded as *visual evidence*. Well, what does a critic do with visual evidence? He or she *analyzes* it to see where it leads.

Analyzing the facts—dealing with visual evidence—is an advanced type of description. It corresponds to describing the relations among the words in a sentence. You may remember learning in school that adjectives modify nouns, that adverbs modify adjectives, and that a predicate tells us what a subject is or what it is doing. In like manner, colors modify shapes, light modifies forms, lines express direction, and textures characterize surfaces. In other words, the juxtaposition and combination of the formal elements—line, light, shape, color, and texture—constitute the *grammar* of visual art. Now, is there a *language* or terminology we can use to deal with that grammar?

The Language of Analysis

Yes, and that language is deceptively simple. The words we use are easily understood, even though they describe complex relationships. For convenience, I have listed some typical terms and paired them under the categories of visual form.

1. *Line:* straight/curved, thick/thin, horizontal/vertical, open/closed, sharp/dull, hard/soft, flowing/jagged, continuous/interrupted.
2. *Light:* day/night, natural/artificial, clear/shadowy, weak/bright, high source/low source, frontal/lateral, focused/hazy, glaring/dim.
3. *Shape:* round/angular, cubical/cylindrical, triangular/conical, flat/stout, solid/broken, measured/irregular, concave/convex, geometric/organic, loose/dense, positive/negative, stable/unstable.
4. *Color and Temperature:* hot/cold, warm/cool, complementary/analogous, primary/secondary, high-key/low-key, mixed/pure, saturated/diluted, advancing/receding, rich/neutral.
5. *Size and Quantity:* great/small, many/few, tall/short, wide/narrow, equal/uneven, heavy/weightless, massive/little, swollen/shrunken, dominant/subordinate, prominent/inconspicuous.

6. *Space and Location:* left/right, high/low, close/distant, above/beneath, first/last, central/peripheral, overlapping/intersecting, shallow/deep, tangent/adjacent, empty/full, limited/boundless.

7. *Surface and Texture:* smooth/rough, hard/soft, dry/wet, coarse/fine, glossy/matte, wrinkled/even, grainy/filmy, porous/sealed, opaque/transparent.

After these *form descriptors* have been used, we can make further observations about similarity, closeness, contrast, sequence, direction, rhythm, symmetry, balance, completeness, and closure. These terms (drawn mainly from Gestalt psychology) deal with *perceived relationships* among forms. They are more abstract than words like "straight" and "curved," but we need them to do formal analysis. Without this terminology, our critical language would be greatly impoverished.

The analytic stage of criticism may also include mention of technical processes. This does not require a lecture on egg-tempura painting, or a disquisition on the lost-wax process of bronze casting. What the critic must attend to are the observable marks and signs of technique—artistic execution. If a critic knows the difference between an etched (bitten by acid) line and a drypoint (directly cut in the plate) line, that's good. If the critic can *recognize* the difference, so much the better. But the differences between these kinds of line should be *visible* if we want to use them in our commentary. Again, visual facts rather than antecedent knowledge should govern discourse at this stage of criticism.

A further hint about the technique of visual analysis. To do it well, the critic must execute a simple psychological maneuver: switch from left-brain to right-brain thinking. For example, when looking at a tree painted by John Constable, we try to forget Joyce Kilmer's poetic line: "Only God can make a tree." Instead, we concentrate on the size, shape, color, and texture of Constable's *painted* tree; we consider how he has located that tree in relation to the land, sky, farmhouse, wagon, and other trees in the picture. In short, we try to see the tree in *visual* context before writing a high-flown piece about English farming life or the presence of God in unspoiled nature. By employing right-brain thinking we may be able to do justice to Constable's tree; otherwise, we shall find ourselves trapped in Kilmer's poem forever.

Finally, it is important to realize that formal analysis has limitations: it does not reach comprehensive meaning, although it may come

close. Our observations of size, shape, and color relationships are semantically suggestive. The critic notices that these relationships seem to manifest behaviors such as aggressiveness, submissiveness, resistance, cooperation, pride, anger, shyness, and so on. Of course, a color by itself may not look bold or angry, but combined with size and shape and seen against other colors, it can embody the very soul of aggression. In other words, formal relations are emotionally and intellectually potent. Sometimes a well-turned analysis of form delivers its own aesthetic judgment, as in this devastating critique of Thomas Benton's painting: "Benton's ideas about 'the hollow and the bulge,' the rhythmical distortion of bone and muscular structure, made his human figures weirdly overdetermined, like lanky dummies with cartoon faces...the very clouds in his landscapes flex their muscles."[2]

Accordingly, before interpreting an artwork as a whole, a critic must consider its formal relationships and their associated feelings and ideas.

INTERPRETING THE EVIDENCE

Interpretation is the crucial third stage of art criticism: this is the point at which our search for meaning reaches a climax. And, while interpretation is difficult, it is also rewarding: our patient critical inquiry finally receives its "payoff."

What is an interpretation? It is a statement—spoken or written— which makes our descriptive and analytic observations "hang together," or cohere. A good interpretation has the effect of "making sense" out of the separate, disjointed, and partial meanings we discovered in the course of our critical exploration. When an interpretation is completed, when it "clicks," we think we know what a work of art means. That knowledge, accompanied by an agreeable sense of certainty, may be a psychological illusion, but we like it and believe we've earned it.

Now, there is an imaginative or creative "leap" from the accumulation of visual evidence to the construction of an interpretation. That leap may feel like jumping into a bottomless pit, so how do we get ready to make the jump? First, we need audacity and a willingness to take chances. But if we feel less than audacious, there are ways to gather one's forces before diving into space.

[2] Robert Hughes, "Tarted Up Til the Eye Cries Uncle," *Time*, May 1, 1989.

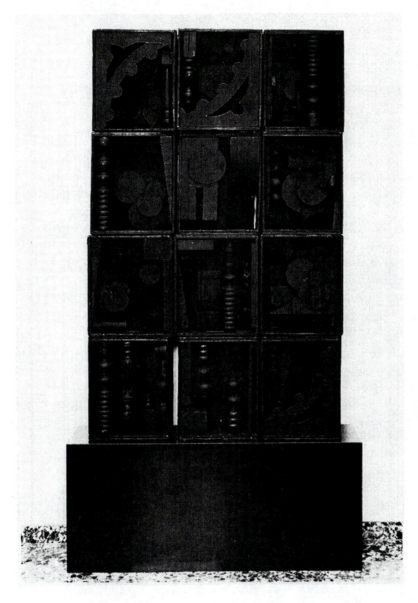

LOUISE NEVELSON, *Black Wall,* 1964. Wood construction painted black, 64 3/4" x 39 1/2" x 10 1/8". The Hirshhorn Museum & Sculpture Garden, Smithsonian Institution, Washington, D.C. Gift of Joseph H. Hirshhorn, 1966. Photographed by Lee Stalsworth.

The aesthetic evidence consists of twelve black boxes of wooden disks, newel posts, balusters, chair legs, and jigsaw carpentry. What can these odds and ends mean? Perhaps the box contents will never give up their secrets, but their overall shapes add up to a wall—a wall made of carefully formed parts that were lost or discarded and then found and reconstructed. Can this be the story of our houses and cities? Perhaps it is the real image of our lives.

A Critic's Hypothesis

To build courage, a trial leap, or *critical hypothesis,* is very help-ful. What is a critical hypothesis? It is an educated guess about the meaning of the work under scrutiny. Why do we call it an "educated guess"? Because we have already studied the work, assembled the visual facts, developed some "hunches" about pieces of the work, and formed some tentative ideas about the work's overall significance. So, our hypothesis is hardly a "shot in the dark"; it has a foundation in fact.

A critical hypothesis also serves as an adaptation device: it tries to reconcile what we have seen with who we are, where we have been, what we have done, and what we think we know. At best, an hypoth-esis facilitates several processes of human growth: it forces perceptual change without too much pain, it encourages the assimilation of new experience, and it helps enlarge the viewer's world.

An hypothesis is also a way of testing or "trying on" an idea to see if it fits. That is, it has to suit us and satisfy the visual evidence at the same time. Now, where do our test-ideas come from? They derive mainly from the intuitions and hunches that accumulated during the descriptive and analytic stages of criticism. Happily, those intuitions came spontaneously; we simply set them aside for use at a later time. Now that time has arrived.

But even with hunches and intuitions, a critical hypothesis does not spring to mind fully formed. Here we can use some questions whose answers can get us into the right frame of reference, the right "ballpark." Following are a few that might be tried while looking at the work:

- Where in the world, or out of the world, is this happening?
- Who lives here? What do they do? Why do they do it?
- Is anything growing? Are these forms dead or alive?
- Are the represented events (forms, creatures) real or potentially real?
- Was this place (form, object, creature) seen, remembered, or invented?
- Where are we situated in relation to what we see?
- What happened before we arrived? What will happen afterward?
- If all this were real, how would our world be changed?

Here is another device which may help in the formulation of a critical hypothesis. Pretend the artwork is a person who has "designs" on you. Then ask yourself one or more of the following questions:

- What is the work trying to sell me?
- What does it want me to admire?
- Whom does it tell me to emulate?
- What does it ask me to do?
- What does it want me to think?
- How does it want me to feel?
- How does it ask me to act?
- What does it expect me to know or believe?

The following set of questions tries to get at the implied public for the work:

- Who does the work think I am?
- Was this work made for a special person? Was I supposed to see it?
- Does the work address me by my age or gender?
- Does it address me by my race or nationality?
- Does it address me by my religion or politics?
- Does it assume I am rich or poor?
- Does it think that I am ignorant or educated, naive or sophisticated?
- Am I supposed to grieve or rejoice? Was this created for winners or for losers?

A final set of questions deals with what might be called "inside baseball."

- Is this work about the artist's life?
- Does the work "talk about" other artists?
- Does the work "talk about" art history?
- Do I recognize the art-game being played?
- Is the work about an old art style? About the birth of a new style? About the death of all styles?

- Is someone being denounced? Is the work competing with something we do not see?
- Is this a demonstration of skill or technique or process? Is it about the making of art?
- Does the subject matter really matter?

You may think of better questions and other devices to stimulate the critical imagination. Their purpose should be the accumulation of hunches that might be helpful in forming an interpretation. I have found that playing hunches or waiting for "flashes" of insight often involves listening to one's body in the presence of the artwork. You can ask, does the image "hit" you in the eyes, the mouth, the scalp, the throat, the stomach, or the knees? In other words, what part of your physical person does the work seem to be aimed at?

Consider your immediate feelings, too. Does the work make you angry, nervous, calm, sleepy, light-headed, anxious to leave, ready to fight? A critic assumes these feelings have sources in the artistic image, sources one ought to revisit. Remember that we are looking for an idea that can explain the total work of art; searching for its emotional engine might pay off.

Artworks also seem to generate sounds; this is especially apparent during visual analysis. At the interpretive stage, the critic can focus on those "sounds" and ask where they come from. For example, do they originate in nature, music, machinery, the city, an empty house, or human voices? Now, critics who hear voices while looking at works of art are not necessarily mad; those voices may be telling them something important, or they may be asking questions that call for answers. Here we should bear in mind that critical interpretation is very difficult. We need all the help we can get, and aid from invisible sources is quite acceptable.

A final source of interpretive ideas comes from the critic's "looks like," "feels like," "sounds like" and "reminds me of" reactions. I believe these half-formed impressions, memories, and associations represent a subliminal effort *to connect* with a work of art. They ought to be trusted or, at least, followed up. How do we "follow up"? We do so by checking our hunches against the visual facts and hoping one of the hunches works out. Perhaps the main difference between good and bad critics is that the good ones have confidence in their intuitions. They know there must be a reason why they feel, think, or remember

as they do while looking at an artwork. And, they are not afraid to use *all* their resources to get what they need.

What is a Good Interpretation?

The answer to this question is superficially easy: a good interpretation fits all the facts together. In practice, that rarely happens. The visual facts are almost infinite in number; our hope is to explain *most* of them.

If perfect interpretations are virtually impossible, can we produce *good* ones? And if so, can they be recognized? Yes. In my opinion, a good interpretation will exhibit many of the following traits:

Completeness: most of the facts have been explained; important features of the work have not been left out.

Persuasiveness: the critic's argumentation is logical and it *feels* convincing; it makes us want to say "yes."

Personal Relevance: the critic appeals to *my* experience rather than inside knowledge or outside authorities.

Durability: the critic's interpretation "makes sense" over time and many viewings.

Emotional Power: the critic's interpretation communicates at the viewer's deepest levels of feeling and awareness.

Intellectual Force: the critic's interpretation makes valid connections between the work of art and the world of ideas.

Insight: the critic's interpretation explains why the work is, or is not, enjoyable to the viewer.

Visual Responsiveness: the image of the work is felt or remembered throughout the critic's explanation.

Originality: the critic's interpretation discovers fresh meaning in the work as it relates to the world we know and the life we have led.

Finally, of course, a good interpretation agrees with the one we have already formed.

To sum up, interpretation has been called the *creation* of meaning, which is true in a sense: critics use imagination, they make original discoveries, and they shape their language artfully. However, critics do not invent out of nothing. An interpretation may be a

"story," but it is a story *about* something that exists; namely, a work of art. The rule we should observe here is that a critical interpretation has to be *confirmable* by other viewers. The best way those viewers can confirm *my* interpretation is by examining the work that I saw. Even then, they may disagree, but at least we shall have considered the same visual evidence. That ought to satisfy the artist, it may give comfort to the critic, and it should serve the public interest.

JUDGING WORKS OF ART

The fourth and final stage of criticism is the evaluation of whole works of art. This sort of judging may seem presumptuous, or perhaps it is downright foolish. There is a sense in which every work of art is one-of-a-kind, and therefore incomparable. But if that is true, we should stop right now: criticism without comparison, or *implied* comparison, seems to me worthless.

Happily, there is another position which maintains that judging a work of art means estimating its value *in relation to* other works of art. Thus, critical judging becomes the business of making intelligent comparisons among objects which are in some sense alike.

"In some sense alike": For us, that implies comparing a work of art with other works of *similar meaning or purpose*. Why is this approach to judgment recommended? Because it is what most people do when they make judgments in everyday life, because it encourages critics to compare art with art instead of art with concepts, and because comparative judging gets us out of the swamp of pure subjectivity, or mere liking. Best of all, comparative judging saves us from saying, "It's good or bad because I say so."

The Comparison Problem

Most shoppers know that we cannot compare apples with oranges. Both are fruit and both are round, but they don't taste the same. Likewise, works of art have much in common, but they don't taste the same, either. So we need a rule that will let us compare art apples with art apples. That is, we want to compare works which belong to the *same art classification*. Art can be classified by period, place, style, medium, culture, religion, subject matter, meaning, and purpose. In art criticism, it is best to classify by meaning and pur-

pose. In this connection, Seitz compared art critics with dog show judges: "As dog fanciers (who do not judge poodles against Pekinese) know better than art critics, each genre has its own criteria of value. Valid comparative judgments can be made only between similar entities."[3]

Of course, any art classification is useful if it is based on objective facts and if it helps reduce our confusion. The virtue of *classification by meaning* is that it cuts across many of the categories cited above. We have already defined criticism as a search for meaning, and we have taken considerable trouble to reach the stage—interpretation—that tells us what an artwork means or says. Thus, when it comes to judging, we should not abandon the meaning-values we have struggled so hard to discover and create.

As for *classification by purpose,* it simply means that comparing a bronze portrait with a watercolor landscape, or a Zuni pot with a Persian carpet, makes very little sense. Notice that these art forms differ in material as well as purpose—indeed, their different purposes may explain their different materials. To compare a pot with a carpet, we would have to ignore their distinctive visual qualities, which would lead to a denial of their artistic identity. My point is that classifying art by purpose is a powerful way of organizing the critic's work in the task of judging.

Let me be more specific. A Zuni pot may say that its maker wants the gods to fertilize her fields with rain and sun and make the corn grow. A Persian carpet, on the other hand, may say that the tribesman who sits on it has been transported to a garden where he receives a foretaste of paradise. Clearly, the meanings of these art objects are different because they have radically different purposes. Thus, it would be unwise to compare them, to say that one is better than the other.

We must establish *similarity of purpose* before we can engage in comparative judgment. And the best way for a critic to know the purpose of a work of art is to figure out what it means. That "figuring out" is called interpretation. When we have interpreted a work, when we know what it means, we are in a position to compare it with similar works. In other words, we are ready to evaluate.

[3] William Seitz, in *Quality: Its Image in the Arts,* ed. Louis Kronenberger (New York: Atheneum, 1969) p. 73.

GROUNDS OF JUDGMENT

Once we have interpreted the work of art, we think we know its meaning, and that has helped us to understand its purpose. But how does that enable us to judge or evaluate? Interpretation directs us toward the *ground of judgment* which seems appropriate for the work we have examined. What is a ground of judgment? It is the type of argument a critic uses to justify his or her opinion of the goodness or badness of a work of art.

What are the main grounds of judgment? That is, what are the categories into which similar works of art can be placed so that they can be fairly compared? I have identified three grounds: *formalism, expressivism,* and *instrumentalism.* Needless to say, other critics use different terms and typologies. What matters here is inclusiveness: we need a set of grounds that has a place for everything. Furthermore, our grounds of judgment should not be biased for or against any period, style, or mode of cultural expression. This final requirement may be the severest test of any set of categories we could devise.

Our first ground of judgment is *formalism,* which corresponds in older philosophies of art to the requirement of beauty or harmony. Today this criterion of art is closely associated with Clement Greenberg, described by Barbara Solomon as "a stubborn defender of 'formalism.' He sees the art of the past century as a search for pure form, a systematic stripping away of subject matter, illusion and everything else he feels is extraneous to art. Driven by an internal, inevitable logic, painting evolved to the point where it finally discovered it wasn't about story-telling or even an artist's feelings, but rather about its own qualities, such as the 'flatness of the canvas.'[4]"

According to formalism, an artwork is good to the extent that its parts cooperate, reinforce each other, and join to form a perfect unity. What makes a formal unity perfect? Three aspects of the answer to this question are (1) it is complex but not confusing, (2) it is balanced but not boring, and (3) it is finished but not overdone. A formalist unity, moreover, is not tainted or compromised by associations with practical life, personal needs, or social concerns. One of the founders of formalist doctrine, Clive Bell, put it this way: "For, to appreciate a work of art we need bring with us nothing from life, no knowledge of its ideas and affairs, no familiarity with its emotions.[5]"

[4] Deborah Solomon, "Catching Up With the High Priest of Criticism," *The New York Times,* June 23, 1991.

[5] Clive Bell, *Art* (New York: Frederick A. Stokes, 1913) p. 25.

Ultimately, formalist excellence depends on the artist's ability to experience the world with great sensitivity, to render what he or she sees or feels with subtlety and skill, and to exercise discriminating taste in choice of themes, materials, and modes of expression.

Formalism also requires sensitivity in the critic; he or she must be able to make the same subtle discriminations as the artist. Indeed, artist and critic need to be closely attuned. Their ability to see, feel, and appreciate the same qualities is due, presumably, to similarities in their backgrounds, temperaments, and education. In other words, formalist critics can recognize and judge formalist excellence because they share the outlook of formalist artists. There is a certain circularity here, which is the main defect of formalist criticism.

Nevertheless, despite its overtones of elitism and narrow frame of reference, the formalist ground of judgment is exceedingly influential. Why? It is influential because it has a foundation in artistic reality: every work of art can be seen as a formal arrangement. Also, many critics share the formalist conviction that pure visual relationships represent the highest type of aesthetic value. However, formalist doctrine also excludes many works of art from serious consideration. By denying the aesthetic validity of religious, political, and utilitarian art, formalism creates an impossible situation for critics: we must deal with art in all its varieties. Accordingly, we need alternate grounds of judgment.

For an alternative, *non*formalist ground of judgment, I have coined the term *expressivism*. According to this standard of value, an artwork should be judged by its capacity to communicate feelings and ideas honestly, vividly, and forcefully. An expressivist critic is not especially concerned with pure form or abstract visual relationships; he or she cares instead about the *validity* and *persuasiveness* of the message conveyed through visual form.

How does an expressivist critic know whether the "message" of the forms is any good? The critic arrives at this knowledge by determining whether it portrays life "like it is," by deciding whether the work stirs the emotions honestly and truly, and by asking whether the artwork "says" something new or important. In addition, the critic judges whether the message has immediate relevance for the critic, for his or her public, or for society as a whole.

A good example of expressivist criticism appears in John Russell's biting critique of Richard Estes' photorealist painting: "What Mr. Estes has to tell us about the Upper West Side, we know already. What his pictures have to offer is the kind of simian mimesis

that passes for cleverness among people who resent the difficulty of high art."[6]

It would seem that an expressivist critic must *trust* the artist. That is, a successful work of art should look like a truthful report of the artist's feelings and experience. Somehow, the artist has to persuade the critic that "this" actually happened, that he or she was really there, that these emotions are not faked. Expressivist critics have to be shrewd judges of the validity of their feelings in the presence of an artwork; hence, the artwork must "ring true." Without that sense of assurance, the expressivist cannot invest his or her emotions, the experience miscarries, and the work fails.

Notice that expressivist critics regard form as a *means to an end,* and that end is truth rather than beauty. To be sure, beauty is a good thing *provided* it does not overlook the facts. The same principle applies to goodness: it cannot be won at the expense of truthful expression. We might say that expressivist critics are mainly impressed by the importance of genuine feeling and adherence to high standards of artistic integrity in visual communication. In short, expressivists refuse to separate intellectual and moral values from aesthetic values.

Instrumentalism is the ground of judgment that locates the goodness of an artwork in its capacity to serve an institution, an institution that is more important than ART. Thus, instrumentalists tend to ask these questions: How effectively does this work promote a religious doctrine, advance a political agenda, satisfy a physical need, or successfully sell a product? Again, form is a means to an end, but this time, the end is the agenda of a church, a government, a political party, or a business firm. Diego Rivera stated the instrumentalist case very clearly: "I want my art to be a weapon . . .In order to be good art, art in this country [America] must be revolutionary art, art of the proletariat, or it will not be good art at all."[7]

Of all critics, instrumentalists seem to have the easiest job of judging. Institutional needs and interests are known in advance, so it is not difficult to decide whether an artwork serves them well. In this context, market research may represent an important adjunct to art criticism: "sales" determine excellence. On the other hand, most of the

[6] John Russell, "An Unnatural Silence Pervades Estes Paintings," *The New York Times,* May 25, 1974.

[7] Diego Rivera, "The Revolutionary Spirit in Modern Art" (1932), in *Social Realism: Art as a Weapon,* ed. David Shapiro (New York: Frederick Ungar, 1973) pp. 64–65.

world's art has been created to serve institutional interests, and much of it is very good indeed. Perhaps instrumentalism is just a better way to stimulate competent artistic production.

Finally, we might ask whether instrumentalist critics are fundamentally hostile to formal values. The answer is yes, if those values are meant to exist for themselves alone, and no, if those values support a "higher" purpose. Perhaps the instrumentalist philosophy of art can be summed up in the folk saying: "Handsome is as handsome does." Instrumentalists are very pragmatic; they will not judge an artwork apart from its ideological, political, or economic effects. On the other hand, instrumentalists are made like the rest of us: they cannot be immune to the intrinsic appeal of visual forms. In other words, some of them may be formalists in instrumentalists' clothing.

One practical problem remains. Are the grounds of judgment mutually exclusive? Can a work of art be appraised according to more than one standard of value? Yes, of course, it can. Does that create difficulties for the critic? It does not, unless the purity of the artist's intentions and the neatness of my categories are at issue. Remember that criticism is a search for meaning: if our search can be advanced by using more than one ground of judgment, so much the better. But as former U.S. President Reagan said, "First, verify the facts."

REFERENCES

Arnheim Rudolf. "Gestalt Psychology and Artistic Form." In Lancelot L. Whyte (ed.), *Aspects of Form*. Bloomington and London: Indiana University Press, 1951.

Atkins, Robert. *Artspeak*. New York: Abbeville Press, 1990.

Baker, Russell. "After Modern, What?" *The New York Times*, September 17, 1991.

Barnet, Sylvan. *A Short Guide to Writing About Art*. Boston/Toronto: Little, Brown, 1981.

Barrett, Terry. "Description in Professional Art Criticism," *Studies in Art Education*, Winter 1991.

Bell, Clive. *Art*. New York: Frederick A. Stokes, 1913.

Berger, John. *Ways of Seeing*. Middlesex, England and New York: Penguin, 1972.

Blakeslee, Sandra. "The Brain May 'See' What Eyes Cannot," *The New York Times*, January 15, 1991.

Carrier, David. *Principles of Art History Writing*. University Park, Pa.: Penn State Press, 1991.

Clark, Kenneth. *Moments of Vision*. London: John Murray, 1981.

Czikszentmihalyi, Mihaly. *The Psychology of Optimal Experience*. New York: Harper & Row, 1990.

Dewey, John. *Art as Experience*. New York: Minton, Balch, 1934.

Donoghue, Denis. *The Arts Without Mystery*. Boston: Little, Brown, 1984.

Esterow, Milton. "Gibberish Tie-in Undergirding Contextual Dynamics of the Arts," *The New York Times*, August 12, 1967.

Feldman, Edmund B. "Formalism and its Discontents," *Studies in Art Education*, Winter 1992.

Gombrich, E. H. *The Image and the Eye*. Oxford: Phaidon Press, 1982.

Gotshalk, D. W. "Form." In *Art and the Social Order*. Chicago: University of Chicago Press, 1947.

Gussow, Mel. "Some Tips On Fine Points of Criticism," *The New York Times*, September 16, 1979.

Holden, Donald. "Why Profs Can't Write," *The New York Times*, February 4, 1979.

Hughes, Robert. "Tarted Up Till the Eye Cries Uncle," *Time*, May 1, 1989.

Isenberg, Arnold. "Critical Communication." In *Aesthetics and the Theory of Criticism*. Chicago: University of Chicago Press, 1973.

Koffka, Kurt. *Principles of Gestalt Psychology*. New York: Harcourt, Brace, 1935.

Kupfer, Joseph H. *Experience as Art*. Albany: State University of New York Press, 1983.

Lipps, Theodor. "Empathy, Inner Imitation and Sense Feelings" (1903). In Melvin Rader (ed.), *A Modern Book of Esthetics*, 3rd ed. New York: Holt, Rinehart & Winston, 1960.

Margolis, Joseph. *The Language of Art and Art Criticism*. Detroit: Wayne State University Press, 1965.

Merleau-Ponty, Maurice. *The Primacy of Perception*. Chicago: University of Chicago Press, 1964.

Newton, Eric. "Art as Communication." In Harold Osborne (ed.), *Aesthetics in the Modern World*. New York: Weybright and Talley, 1968.

Pepper, Stephen C. *The Basis of Criticism in the Arts*. Cambridge, Mass.: Harvard University Press, 1949.

Reiner, Albert. "Language Is in the Mind as Well as the Mouth," *The New York Times*, March 4, 1980.

Rivera, Diego. "The Revolutionary Spirit in Modern Art," (1932) in *Social Realism: Art as a Weapon*, David Shapiro, ed. New York: Frederick Ungar, 1973.

Sayre, Henry M. *Writing About Art*. Englewood Cliffs, N.J.: Prentice-Hall, 1989.

Seitz, William. *Quality: Its Image in the Arts,* Louis Kronenberger, ed. New York: Atheneum, 1969.

Smith, Roberta. "Narrow Notions of Greatness at the Modern," *The New York Times,* June 23, 1991.

Solomon, Deborah. "Catching Up With the High Priest of Criticism," *The New York Times,* June 23, 1991.

Stolnitz, Jerome. *Aesthetics and Philosophy of Art Criticism.* Boston: Houghton Mifflin, 1960.

Trippett, Frank. *"Why So Much Is Beyond Words,"* Time, July 13, 1981.

Zee, Anthony. *Fearful Symmetry: The Search for Beauty in Modern Physics.* New York: Macmillan, 1987.

*P*ROBLEMS OF INTERPRETATION

WHY INTERPRETATIONS VARY

Different viewers assign different meanings to works of art, and, for some people, that constitutes a scandal. The implication is that criticism, unlike science, is wholly subjective and hence unreliable. Or, critics play a game that has no rules. Or, meaning in art is so transient and ephemeral that it cannot be captured. Or, the meaning of an artwork is pretty arbitrary; critics "get together" and agree on an interpretation that suits their personal interests. That interpretation then becomes the official meaning of a work even though it is not the "correct" meaning.

There may be some truth in these suspicions. Nevertheless, it should be pointed out that science often uses inexact concepts and meanings, such as "perfect" vacuum and "absolute" zero in physics, "class consciousness" in sociology, or "moral relativism" in cultural anthropology. We might even question the concept of "event" in history. My point is that every discipline has axioms and postulates. Notwithstanding elements of arbitrariness in the sciences, we are not

about to say that "perfect vacuum," "radiant energy," "middle-class taste" and "situational ethics" are meaningless notions. They make intelligible discourse possible in their respective disciplines. Furthermore, that discourse often exhibits a precision of meaning which is *greater than* the precision of its basic assumptions.

The above-mentioned charges against criticism can be refuted more specifically. First, even science is frequently arbitrary in its conclusions as well as its guiding assumptions. Consider the current disagreements about global warming, or the imminence of a new ice age, or the apparent conflict between wave and particle theories of energy. Second, competent critics play the "game" with rules which, like scientific concepts, are under continuous scrutiny. Third, critical interpretations do vary, but that is probably a good thing. Why should the meaning of a work remain fixed when everything around it is changing? Fourth, critics do read each other, often with profit for themselves and for others.

Thus, critics can arrive at a consensus, which is not necessarily sinister; it may only reflect good reasoning from the same evidence. Furthermore, societies need consensus from time to time in order to take effective action. For example, our consensus about the germ theory of disease has been immensely beneficial for mankind. Perhaps a consensus about the meaning of Michelangelo's *Creation of Adam* is less urgent where life and death are concerned. On the other hand, Michelangelo's images of God and Adam may turn out to be meaningful in human affairs long after the germ theory of disease has given way to information theory as the best explanation of why we get sick.

For purposes of critical interpretation, what do these observations imply?

1. Language is often imprecise when it comes to defining scientific and aesthetic phenomena. We needn't worry about it.
2. Our basic concepts may be inexact (consider "form," "space," "rhythm," "optical representation," "illusory image"), yet they can lead to defensible interpretations of specific works of art.
3. Critical discourse tends to grow in precision of meaning as the discourse goes forward. That is, our interpretations become sharper *as we speak*.
4. Critical commentary resembles pictorial expression; both depend on context—visual context for the artist and verbal context for the critic.

5. The full meaning of an artwork is not known in advance by the artist. He has to finish the job in order to know what he or she has made.

6. The full meaning of an artwork is not known by a critic until it has been verbally formulated. Talk usually adds to understanding.

Finally, when teaching criticism, do not be distressed when student interpretations vary from each other. Instead, try to discover their common features. Find out, also, whether the differences among student interpretations reflect different sets of facts or different understandings of the facts. Next, determine whether their facts are facts—that is, visually confirmable phenomena. If their inferences from these phenomena turn out to be original and valid, reward your students for insight and courage. Then, if it is not too painful, try to learn from what they have said.

WORDS AND MEANING

The main difference between art critics and literary critics is that *they* use words to explain words, whereas *we* use words to explain images. We have to be fluent in two languages while they can get by with one. That may be unfair, but there is no way around it.

Actually, meanings exist before words. If we had to, we could convey the approximate meaning of an artwork through gesture, pantomime, or perhaps by semaphore signaling. Charade players know this; they also know that nonverbal communication is very difficult. As for communicating a critic's *understanding,* words are virtually indispensable.

Because art critics have to build bridges between languages, they are often thought of as translators. But that is misleading: art critics teach us to read "in the original." Critics do not translate an artist's "text"; they determine its *meaning* and try to explain it to a particular public. These operations—determining and explaining—entail the use of verbal language, so art criticism is a type of literary effort. Sometimes it even sounds like poetry. On this point, Hilton Kramer notes that "there was a period in the fifties when it was stylish for art critics to write as if they were bad poets, which indeed some of them

were.[1] However, good critics usually resist the temptation to wax poetical; it is better to serve a "text" than to create a competing text.

Here we should clear up a common misunderstanding about artistic meaning and critical talk. Art forms convey meaning, and critical talk conveys meaning, but these meanings are not necessarily the same. So, the question arises: What is the "real" or "correct" meaning of an artwork? Some critics think the "correct" meaning is what the artist *intended*. Naturally, many artists subscribe to this view. In my opinion, however, it is a mistaken notion: artistic intent does not necessarily coincide with artistic *expression*; artistic expression does not necessarily coincide with critical *understanding*; and critical understanding does not necessarily coincide with critical *explanation*. Critical language is, to some extent, part of the problem.

What else causes our difficulties? Although artistic intention governs artistic decision making, it does not govern what is produced, it does not govern what is understood, and it does not govern what critics say afterward. Why? The answer could be stated, "There is many a slip 'twixt the cup and the lip." That is, much happens between intention and execution. And, artists must employ *conventions* when making art—conventions like outline, perspective, color contrast, and modeling with light and dark. These conventions carry inherent meanings no matter how much the artist tries to control them. Thus artists have to work with two languages—a language of independently created forms, and a language of received or inherited conventions.

If my analysis is correct, a critical interpretation must deal with two types of meaning: (1) the meaning of the forms created by an artist; and (2) the meaning of the conventions employed by an artist to organize the forms the viewer sees. The *mixture* of these meanings in a final interpretation varies from critic to critic. And that variation is legitimate: it reflects the critic's judgment about the relative roles of invention and convention in any artistic creation. In addition, it reminds us that every artist, no matter how original, works with agreements or tacit understandings—materials that are *not of his or her own invention*.

Clearly, art critics use language—more than one language—in doing their work. As for the language of words, it can give us the sig-

[1] Hilton Kramer, "Writing About Art," *The New York Times*, June 4, 1972.

nificance but not the sensation of colors, shapes, and textures. As we have said, words are pointers; they are best used to indicate a *range* of meaning. Beyond these reservations, what can we say insofar as words and meaning are concerned?

1. Words are tools of investigation; terms like who, what, where, when, and how give focus to visual inquiry.
2. Once a visual inquiry is begun, words fix or "baptize" the forms we see; naming things helps us to reflect on their "behavior."
3. Words enable us to break down visual structures, and that helps us to notice what is "there" as opposed to what we expect to see.
4. Words help us to build bridges between sensory impressions, prior experience, logical inferences, and the tasks of interpretation and explanation.
5. Artworks do not surrender their meanings easily; we need words to *extract* meaning from artistic matrices.
6. Words in the aggregate provide critics with "test" structures that can be used to try out the meanings embedded in artworks. In short, words help us to guess intelligently.

Perhaps words are vague and imprecise as descriptors of aesthetic phenomena, but collectively they "add up" to meaning. Better stated, words *converge* on or "close in" on meaning. Thus verbal vagueness can be an asset; it may even clarify a critic's understanding and point the critic in the right direction. However, do not interpret this to mean that I am advocating fuzzy speaking or writing: indeed, critics should try to make their meaning as clear as possible.

SEEING MEANING

"Seeing" meaning reminds us of the well-known tree that falls in the forest: Does it make any noise if no one is there to hear it? Our answer is that a noise *potential* is created by the falling tree, but a human ear is needed to realize that potential. A tape recorder will not do: it picks up sound waves but it doesn't understand "noise." The same is true with a work of art: a meaning potential is present in a painting, but a human critic is needed to realize its significance. A camera will not do: it can reproduce the image but it does not realize

what a picture *means*. Following this idea, what types of meaning do critics "realize"?

The first type is *indicative* meaning. A critic points to some forms—let us say the rounded forms in a painting by Franz Marc—and declares: "There are three blue horses in front of two red hills." This is an elementary type of inference, to be sure, but it is meaningful nevertheless.

A second type of meaning might be called *use* meaning. Thus a critic looks at a Chardin still life and says: "Those are the well-worn pots and pans of a typical French kitchen." Even without knowing the kitchen is French, the critic can see, or *realize*, that the utensils are meant for cooking (good cooking!) and that they aren't new.

A third type of meaning can be called *relational* meaning. Looking at Modersohn-Becker's *Mother and Child,* a critic might say: "The body of the nursing baby is a small copy of the mother's body." The critic could go on to talk about infant nourishment and maternal love, but these are derived ideas that rely on the prior perception of a significant—that is, meaningful—size and shape relationship between the two bodies.

A fourth type is *syntactic* meaning—meaning that depends on location or sequence in space. For example, Picasso's *Guernica* shows a terrified woman holding her dead child *directly beneath* the head of a bull. The bull, of course, is a symbol of violence and war; by his location, he becomes the "killer" of the child. A *spatial* relationship is seen as a *causal* relationship, and that produces the meaning we see.

Le Corbusier's *Chapel at Ronchamp* exemplifies a fifth type, *symbolic* meaning. Seen from the side, the roof of the chapel looks like a fish, and a fish is an early symbol of Christ. Of course, a critic would have to know something about Christian iconography *in advance* of seeing the chapel. On the other hand, the shape of a fish, or a boat, is quite clear in the building. Given that image, it's not difficult to "see" Noah's Ark, the "ship" of St. Peter, or the Catholic Church "swimming" through the seas.

We can see a sixth type of significance, which I call *metaphorical* meaning. Consider Edvard Munch's *The Scream.* Here a critic might say the blue-black shape behind the main figure is the "death shroud" of someone who is about to commit suicide. Is this merely a psychological projection? It is not, if we examine the plain black dress of the screaming person; it reinforces the perception of a shroud. Indeed, there appear to be *two* shrouds in the painting: one is the dress and

the other is the water shape that will swallow up the suicide. The more we look, the stronger the metaphor becomes.

A seventh type, *sensuous* meaning, designates the meanings we see even though they derive from the other senses. For example, a Millet painting can give us the smell of newly turned earth or fresh-cut hay. We can also see damp skin in a Rubens and dry skin in a Holbein. A Stuart Davis canvas can convey the sounds of syncopated jazz; similar sounds can be "heard" in Picasso's *Three Musicians*. As for tastes, a Dutch still-life might give us the flavors of meat, fish, fowl, fruit, vegetables, cheese, and wine...plus a warning that these savory pleasures are fleeting as we see them.

A final type is *sexual* meaning. We can see and feel it in many kinds of art—ancient and modern, elite and popular, high and low. Little needs to be added beyond the fact that erotic imagery proves my point: its visual structures are cognitive and affective at the same time.

These meaning-types represent only a sampling of what art critics can legitimately perceive. Other meaning-types might be described, but my main purpose is to show that interpretation is not a clever game of self-deception. There are objective structures in works of art—visual facts in visible relationships—that justify our claims to perceive the meanings we talk about. Of course, we must defend against seeing ghosts—which is why we insist on careful observation before launching into interpretation. After that, we can worry about using a suitable logic of explanation.

THE PROBLEM OF EXPLANATION

We use "interpretation" and "explanation" interchangeably, but these terms are not, strictly speaking, identical. An interpretation is a critic's *understanding* of a work of art; an explanation makes that understanding comprehensible to interested viewers.

Now let us imagine a critic who has understanding, or *verstehen*: he or she is knowledgeable and insightful at the same time. This critic believes he or she has correctly interpreted a work of art and now is faced with the task of explaining it. But how does the critic make the leap from understanding, or *verstehen*, to explanation, or exegesis?

The critic does not make this leap by bludgeoning the audience with facts, even if they are valid. The critic does not do so by sharing his or her feelings, even if they are sincere. Our critic, being wise, knows three things: (1) facts do not *of themselves* add up to under-

STUART DAVIS, *Rapt at Rappaport's,* 1932. Oil on canvas, 52" x 40". The Hirshhorn Museum & Sculpture Garden, Smithsonian Institution, Washington, D.C. Gift of the Joseph H. Hirshhorn Foundation, 1966. Photographed by Lee Stalsworth.

Sensuous meaning. Sometimes we *hear* music while looking at painted forms. For example, this canvas *sounds like* jazz. Why? Perhaps it is because of the staccato shapes. What are "staccato" shapes? They are shapes that exhibit sharp, abrupt changes of edge, color, and direction. That should help us explain the Stuart Davis painting.

standing; (2) understanding does not *of itself* constitute explanation; and (3) sharing feelings, while enjoyable, may tell more about the critic than the artwork. What our critic needs is a grasp of the various *types of explanation.* Then he or she will know how to use facts and feelings effectively.

Types of Explanation

Following is a list of the main types of critical explanation supported (it is hoped) by pertinent artistic examples. I cannot say that one explanatory type is necessarily better than another, only that it fits the work given as an illustration. In practice, a critic would choose the type that seems most appropriate in the light of her understanding and her perception of the public's needs.

Material Explanation. The meaning of the work is substantially determined by the character of its physical materials. The bent, crushed, and welded auto parts of Chamberlain's *Essex* express the ideas of aging technology and metallic death because the sculpture is made of used and discarded or "dead" metal.

Technical Explanation. The process of making an image accounts for the feelings it expresses. Thus, Nolde's woodcut, *The Prophet,* creates a painful effect because of its harsh, angular shapes, which are caused by the way the wood grain on the plank side of the block resists the printmaker's cutting tools.

Mechanical Explanation. The form of the object is understood as an answer to a physical challenge. Thus the shape and proportions of a Gothic pointed arch represent a solution to the problem of directing the weight of a stone vault downward instead of outward.

Utilitarian Explanation. The appearance of the object is determined by the way it is used or by the habits of its users. Thus, a Breuer chair is made of steel, and a Hans Wegner chair is made of wood. However, the character of each chair is ultimately governed by the way our bodies are formed and our notions about the right way to sit.

Official Explanation. Here explanation is a type of bureaucratic "spin." We get the authorized version of a work, its ritual function, or its ceremonial purpose. Thus, Goya's *Family of Charles IV* is a digni-

fied portrait of the Spanish royal family in 1800. What we really see is a portrayal of the queen's ugliness, the king's stupidity, and the witlessness of their progeny—which is an *unofficial* explanation of the work.

Intentional Explanation. The critic reports and accepts what the artist said about why he created the work. Concerning *The Spirit of the Dead Watching,* Gauguin wrote that he wanted to capture a Tahitian girl's "fear" and "terror" as she felt the death spirit ("an ordinary little woman") watching her.

Legitimizing Explanation. The work is construed as a legal instrument like a will or a deed, or an authorizing symbol like the Queen's portrait in an English courtroom. Thus, Van Eyck's *Arnolfini and His Bride* is a marriage contract which depicts the couple's wedding ceremony while symbolizing their marital obligations, spiritual aspiration, and expectations of offspring.

Model or Type Explanation. The work is characteristic of a certain mode of artistic expression; it is the first, best, or most frequently cited exemplar of its type. Thus, Braque's *The Portuguese* is a model of the Analytic Cubist style; other works in the style are variants or "replays" of the type.

Scenario Explanation. The work is viewed as a scene—perhaps the crucial scene—from an ongoing story, play, or film. For example, Winslow Homer's *The Gulf Stream* can be seen as an excerpt from a drama featuring a storm at sea, a damaged boat, sharks circling around a boat, and a black fisherman lying exhausted on the deck.

Therapeutic Explanation. The work is seen as a restorative or as medicine; it heals viewers by changing their spiritual orientation. Thus, Grunewald's *Isenheim Altarpiece* cures or improves the condition of lepers and syphilitics as they contemplate the wounds of the crucified Christ.

Ideological Explanation. The meaning of the work grows out of a system of ideas—usually political—held by the artist. For example, *The Outbreak* by Kathe Kollwitz presents a sixteenth-century German agrarian uprising as an episode in a presocialist struggle for the rights of labor. Especially important is the attention given to a woman, Black Anna, the fiery leader of the peasants.

YVES TANGUY, *Naked Water*, 1942. Oil on canvas, 36 1/4" x 28". The Hirshhorn
Museum & Sculpture Garden, Smithsonian Institution, Washington, D.C. Gift of
Joseph H. Hirshhorn, 1972. Photographed by Lee Stalsworth.

Theoretical explanation: Tanguy's world can be understood as the visualization of a
set of circumstances that logically produce the light, air, water, land, creatures, and
things we see. In this mode of explanation, the critic's role is to reason back from the
forms to the real or supposed conditions that caused them.

Predictive Explanation. The work functions as an oracular or prophetic statement; it foresees new social conditions or a new way of thinking about humankind. Thus Picasso's *Les Demoiselles d'Avignon,* completed in 1907, anticipates the breakdown of European ethnocentrism a half-century later.

Theoretical Explanation. The work is understood as the product of a set of conjectural or suppositional conditions. Thus *Infinite Divisibility* by Yves Tanguy depicts fantastic living creatures which have bones but no flesh, are partly mechanical, and exist in a world illuminated by several suns. Under the circumstances, Tanguy's "world" seems perfectly plausible.

Teleological Explanation. Every feature of the work is shaped by its goal or "final cause" (in Aristotle's terminology). Thus, the swords, the hard figures, the bare walls, and the cold light of David's *Oath of the Horatii* create an image whose purpose is to prepare the French people for the rigors of revolutionary conflict.

It would appear that in addition to being an intelligent viewer, a critic must be a good explainer. The trick is to explain works of art in terms that "make sense." Making sense might be called *building verbal bridges,* an operation that requires three things: (1) understanding of the work, (2) empathy with the spectator, and (3) knowledge of the principal explanatory strategies. The rest is tactics. And here I think teachers are the ones we can learn from: they are great tacticians because they have to be.

A TEACHER'S EXPLANATION

Compared to other critics, a teacher is a live performer: he or she works *in the presence of* his or her public. Teacher-critics *see* their audience, which, in turn, sees them. This creates a situation that affects pedagogical criticism uniquely: a teacher-critic knows his or her students, watches their reactions, hears their responses, and feels an obligation to *make himself or herself understood.* Scholars and journalists have the same obligation, but I don't know if they feel it as intensely.[2]

[2] Friedlander's comment is appropriate here: "Scholars are satisfied when they themselves understand what they have written; they do not think of the reader." (Max Friedlander, *Reminiscences and Reflections, op. cit.,* p. 38.

Like other critics, teachers must understand an artwork before attempting to explain it. However, it is equally important to understand the students *to whom* the explanation is addressed. Obviously, I have some trouble with the concept of a *universal* explanation—an explanation that suits everyone always. To me, an explanation is contingent on (a) the meaning of the work at a certain time, and (b) the understanding (or capacity for understanding) of a particular public. An ignorant critic tends to neglect (a), while a scholarly critic tends to neglect (b). But a pedagogical critic has to deal with (a) and (b) at the same time.

To some extent, a teacher's explanation depends on who the student is, what the student knows, and how the student sees the world. Therefore, to explain and be understood, a teacher-critic needs some ideas or intuitions about where his or her audience "lives." Here empathy, or identification with the student is crucial: without it, one can lecture but one cannot truly teach.

Why does explanation call for empathy? First, because the teacher-critic needs to "get into" the work, to breathe in its atmosphere, to explore its space, to feel its tensions, and to hear what it is saying. This sort of empathy discovers the "stuff" that has to be explained; it requires a projection of the self into the world represented by the artist. A critic has to feel "at home" in that world—at least temporarily—in order to play host to his or her students.

A second type of empathy might be called *linguistic.* As mentioned above, we employ words to build bridges between an artwork and its viewers. In the case of student viewers, we need the *right* words—which means words *they* understand—and, more importantly, words that *make connections* with their experience. Word selection is crucial, as Mel Gussow points out: "Q. What is the biggest problem of being a critic? A. Words. They lose their credibility and currency. Every critic needs new words. There should be a word bank where you could trade in worn-out words."[3]

How can we connect with student experience? We cannot do it by behaving as they do; we are no longer their age. So we have to "feel" our way into their consciousness. That is, we have to perceive an artwork *as if* we were seeing it through their eyes. This is not an optical trick: it is a feat of imagination; it is a part of the "art" of teaching.

[3] Mel Gussow, "Some Tips On Fine Points of Criticism," *The New York Times,* September 16, 1979.

Finally, a teacher has to anticipate the questions that students are likely to ask about a work of art. The teacher need not know the answers, but he or she needs some realistic ideas about the direction of the discourse. Here a certain amount of evasion is pedagogically useful: students should be encouraged to initiate *their* inquiries, gather *their* evidence, make *their* guesses, and fashion *their* interpretations. Then they can try to reconcile their differences in a final, collective explanation. When these things are done, the students will have learned something—something that goes beyond art criticism. And, their teacher will look very good indeed.

MIDRASHIC EXPLANATION

Midrash is a Hebrew word meaning the exposition, or free interpretation of sacred scriptures. There are three main types of midrash: (1) translation and compilation; (2) exegesis, explanation, and commentary; and (3) paraphrase, parable, and prophecy. It is mainly the second type that interests us here: our "scriptures" may not be sacred, but they are just as difficult to explain. Perhaps we can use the help of the rabbinic explainers.

The ancient midrashists worked on the basis of religious faith. That is, they saw their task as finding the meanings—often the *hidden* meanings—of divinely inspired texts. If the texts disagreed, then they had to be reconciled. It was the process of reconciliation that produced the *midrash,* or, as we would say, the critical explanation.

Now, the necessity of reconciling conflicting or inconsistent texts led to a result that is well known to modern critics: the original meaning of a text and the "absolutely correct" interpretation of a text always eludes us. However, that is no reason to stop trying. Besides, an interpretation that is approximately right is better than one which is egregiously wrong.

The midrashic literature is immense if only because it confronts a vast array of problems: incomplete texts, obscure texts, embroidered texts, mistranslations, obsolete usages, changed social conditions, and scribes with special agendas. In the course of handling these difficulties, the midrashists developed skills that are not unlike those used in criticism. We, of course, deal with visual images, not "texts." However, we share at least one problem with the midrashists, the problem of exegesis: how to interpret and explain a "text" so that people will understand its meaning in their lives.

"Meaning in their lives:" this phrase opens the door to a considerable amount of creativity. Why? Because it takes a great deal of ingenuity to put a text into the right context. And, that is where the arts of midrash and criticism converge: both try to clarify the meaning of their "sources" in the light of contemporary needs, circumstances, and understanding. To use a popular term, both critic and midrashist have to make their subject "relevant."

In the following list I apply the major principles of midrash to the problems of art critical explanation. Where the word "text" is used the reader should substitute "work of art."

Addition or Interpolation. If we add certain material to a "text" it makes better sense. For example, in a midrash on an assemblage of black boxes by Louis Nevelson, we might introduce the notion of looking at an ancient ruined wall. It is a wall that describes the destiny of all civilizations: destruction followed by the orderly accumulation of relics.

Subtraction or Omission. The elimination of certain material in the "text" clarifies its essential meaning. Thus, in a midrash on Pavel Tchelitchew's *Hide and Seek,* we might set aside the reference to a child's game and speak instead of life's beginnings in the womb and in tree roots, followed by life's flowering in leaves, babies, and butterflies.

Symbolic Inquiry. We assume that the "text" contains a secret meaning, and that meaning can be known if we find out what its surface features "really" stand for. Thus, a midrash on Monet's *Water Lilies* (*Nymphéas* in French) might say that the lilies represent beautiful young women; the artist makes love to them as he paints them in his garden. His garden, of course, is paradise.

Analogy. The situation *in* the "text" is similar to a situation we have encountered *outside* the "text." Accordingly, a Jackson Pollock canvas leaves us mystified until we realize that we have seen similar tangles and knots before—in a ball of yarn "attacked" by a cat, in a late-afternoon traffic jam, in the desperate graffiti on an inner-city wall, in the spills and splashes of an exploded container of paint. That's the midrash: Pollock was himself an explosion of paint.

Allegory I. The "text" consists of concrete details used to convey an abstract idea. Thus a midrash on the physical deformity of Rouault's judges and prostitutes would maintain that they embody the moral depravity of modern man and society.

Allegory II. The "text" consists of abstract details used to convey a real or concrete series of events. Thus, a midrash on the abstract forms in Gottlieb's "blast" and "burst" paintings would say they describe a scene in which a "beautiful" cloud rises above a "dirty" nuclear explosion.

Prophecy. The "text" describes the fulfillment of a divine prediction, transmitted by an ancient prophet but expressed in modern terms. Thus, we have the prophecy of Isaiah—"The lion shall lie down with the lamb"—literally illustrated in Edward Hicks' *The Peaceable Kingdom.* However, Hicks "improves" on the original by adding a scene showing William Penn and his Quaker brethren peacefully negotiating with the Indians. In this case, Hicks does the midrash.

Commentary. The "text" is a platform from which we can launch a discussion of issues related to its imagery. Thus Manet's *A Bar at the Folies Bergere* opens up the topic of employing attractive women to sell goods in a fashionable setting. Manet may not have anticipated this line of inquiry, but we have the right to pursue it nevertheless.

Perhaps these brief *midrashim* (plural of *midrash*) sound somewhat far-fetched. Alas, that is one of the hazards of our profession. Still, one might ask if there are any limits to what a critic can safely say. According to the First Amendment to the Constitution, there are hardly any.[4] All we can say in extenuation of our sins is that (1) no interpretation is absolutely true to its source, and (2) free interpretation is what keeps original "texts" alive. Thus, extravagant explanations do some good after all.

[4] Four centuries ago, Montaigne made a similar observation about the endless possibilities of interpretation: "Once you start digging down into a piece of writing there is simply no slant or meaning—straight, bitter, sweet, or bent—which the human mind cannot find there." (Michel de Montaigne, *Essays,* 1572.)

EDWARD HICKS, *Peaceable Kingdom*, c. 1834. Oil on canvas, 29 3/8" x 35 1/2". National Gallery of Art, Washington, D.C. Gift of Edgar William and Bernice Chrysler Garbisch.

Here it is the artist who creates the midrash. That is, Hicks portrays the "lion and lamb" verse from Isaiah as an anticipation of William Penn's negotiation with the Indians. To those of us in the field of criticism, this is "prophetic explanation."

REFERENCES

Clark, Kenneth. "Art History and Criticism as Literature." In Clark, *Moments of Vision*. London: John Murray, 1981.

Danto, Arthur C. *The Philosophical Disenfranchisement of Art*. New York: Columbia University Press, 1986.

Feinstein, Hermine. "How to Read Art for Meaning," *Art Education*, vol. 42, no. 3, 1989.

Feldman, Edmund B. *Thinking about Art*. Englewood Cliffs, N.J.: Prentice-Hall, 1985.

Gombrich, E. H. "Dilemmas of Modern Art Criticism." In *Reflections on the History of Art*. Berkeley/Los Angeles: University of California Press, 1987.

Gussow, Mel. "Some Tips On Fine Points of Criticism," *The New York Times*, September 16, 1979.

Hirsch, E. D., Jr. *Validity in Interpretation*. New Haven and London: Yale University Press, 1967.

Horton, Susan R. *Interpreting Interpreting*. Baltimore and London: The Johns Hopkins University Press, 1979.

Kaelin, E. F. *An Aesthetics for Art Educators*. New York/London: Teachers College, Columbia Press, 1989.

Kaplan, Abraham. *The Conduct of Inquiry*. San Francisco: Chandler, 1964.

Kramer, Hilton. "Writing About Art." *The New York Times*, June 4, 1972.

Krieger, Murray. *Words about Words about Words*. Baltimore and London: Johns Hopkins University Press, 1988.

Mitchell, W. J. T. (ed.). *The Language of Images*. Chicago/London: University of Chicago Press, 1974.

Neusner, Jacob. *What is Midrash?* Philadelphia: Fortress Press, 1987.

Ogden, C. K., and I. A. Richards. *The Meaning of Meaning*, 8th ed. New York: Harcourt, Brace, and Jovanovich, 1946.

Panofsky, Erwin. *Studies in Iconology*. New York: Oxford University Press, 1939.

Podro, Michael. *The Critical Historians of Art*. New Haven: Yale University Press, 1982.

Preziosi, Donald. *Rethinking Art History*. New Haven: Yale University Press, 1989.

Richards I. A. *Interpretation in Teaching*. New York: Harcourt, Brace, 1938.

Spitz, Ellen Handler. *Art and Psyche: A Study in Psychoanalysis and Aesthetics*. New Haven: Yale University Press, 1985.

ISSUES
IN CRITICISM

THE PROBLEM OF QUALITY

Critics, historians, curators and collectors use the word *quality* almost continually, although it would be difficult to get an agreement from them about what it is. The dictionary definition—"excellence among things of the same kind"—tells us what the word means, but that doesn't reconcile our differences about the concept itself. Some of us think quality is what art is all about; others think the whole idea should be buried.

Perhaps we can cope with the problem by facing up to certain controversial questions: Is quality *in* the object, or is it a matter of subjective taste? Does quality vary from culture to culture? Would art teaching, art making, and art collecting be possible without a quality concept? And, finally, is quality a weapon used to deny the value of art created by people who lack power and influence?

Before dealing with these questions, let me make one preliminary observation. The wide use of the word quality suggests that the con-

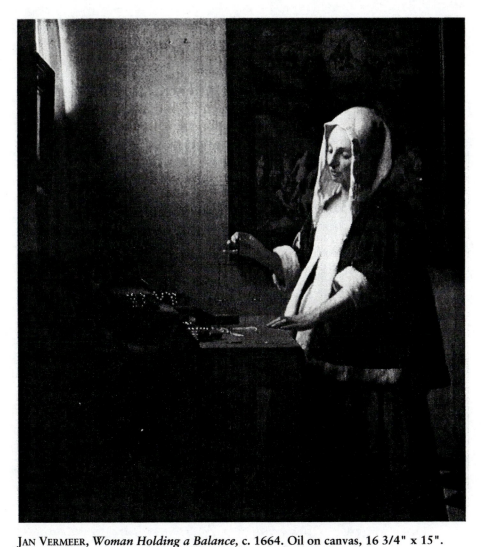

JAN VERMEER, *Woman Holding a Balance*, c. 1664. Oil on canvas, 16 3/4" x 15".
National Gallery of Art, Washington, D.C. Widener Collection.

Forget the allegory and consider only the construction in paint. Surely the woman's
white cowl and surplice constitute a triumph of technique. As for the hand that holds
the scales, it is more than a hand: it speaks of perfect balance—in life and in art; it
represents an exquisite moment frozen in time; it makes our heart skip a beat. This lit-
tle canvas proves, I believe, that artistic quality is real and that it lives in the work.

cept, at least, is deeply routed in human nature. That is, we love the
work of our hands, we like to own good things, and we believe we
know excellence when we see it. These habits and attitudes may or
may not be justified, and they may conceal some unattractive human
traits like egotism and unwarranted confidence in our personal tastes.
Nevertheless, people behave *as if* the possession of, or association

with, excellence is very important in their lives. So, however we use it, the idea of quality if not likely to go away.

Now, to our first question: *Does quality reside in the object, or is it a matter of taste?* The answer is: both. The quality or excellence of an artwork can be defined as a function of its craft or manufacture. Thus a sculpture that splits, a painting that peels, or a print that fades can be judged poor in quality no matter how well it was conceived.

But suppose an artwork does not split, peel, or fade; suppose it is made well enough to last forever. Does its quality then become a matter of a critic's taste? The answer is a qualified "yes." We need to be assured that the critic's taste has been rightly exercised. If it is only a matter of custom, impulse, or passing fancy, it isn't worth very much. We would like to think that a critic's taste is based on serious grounds of judgment such as those sketched out in Chapter Two. In that case, a taste judgment can be defended—even if we wish it had turned out differently.

I believe that quality does have an objective character, if only in a physical sense. There is little doubt that we make quality judgments with respect to materials and workmanship. But beyond appraisals of craft and physical durability, we also make taste judgments about aesthetic "content." These can be regarded as quality judgments, and they should be based on grounds of value such as those already described. There is, however, another point of view, which maintains that taste or a sense of quality is innate, inherited, or determined by one's culture[1]—which is to say, everyone's taste is fixed in advance of judgment. That opinion, which lies close to the heart of the quality controversy, will be discussed at the end of this section.

Question two: *Does quality vary from culture to culture?* Of course it does. Every culture has a quality concept—its own or one it has borrowed. In all societies, people do their work and make their choices according to generally shared ideas of excellence. This is well understood by archaeologists and anthropologists, who can place a pot in a certain time and place on the basis of the way people "have always made" pots in that time and place. Even aboriginal pot makers make taste judgments. However, the choices available to them are lim-

[1] The formalist Roger Fry seems to support this view when he says: "In proportion as art becomes purer, the number of people to whom it appeals gets less.... It appeals only to the esthetic sensibility, and that in most men is comparatively weak." (Roger Fry, "Pure and Impure Art," in *A Modern Book of Esthetics*, ed. Melvin Rader, New York: Henry Holt, 1935, pp. 264–271.

ited, so their tastes are exercised almost automatically. This is why archaeologists can identify their work with so much accuracy.

But if a people's artifacts are highly predictable, there is still a range of quality *within* their various craft traditions. In other words, some Navaho women are better potters than others; this is certainly well known among the Navaho. The same was true among the ancient Athenians and Corinthians: they knew the best potters *within* their respective traditions. In a sense, every Athenian or Corinthian was a connoisseur of the art of pottery. For us, the quality argument arises when it comes to deciding whether Athenian pots are better than Corinthian pots. At that point, an archaeologist is not enough: we need an art critic.

From the archaeological and anthropological evidence it appears that (1) artistic production in traditional cultures follows common standards of quality, and (2) those standards are remarkably stable and uniform. However, traditional standards change in response to invasion, migration, exchange of goods, and independent invention. This tells us something about taste in *complex* cultures: because of war, trade, travel, and commercial competition, complex cultures support multiple ways of art making and multiple standards of quality. That is obviously the case in *our* kind of culture, the sort of culture that produces artistic fashions and so-called arbiters of taste. Because there are so many choices to make, we have developed specialists to tell us what to like.

Apparently, when a cultural situation is sufficiently complex, connoisseurs or mavens emerge spontaneously.[2] Mavens make taste judgments which, in the aggregate, generate standards of quality. However, standards of quality come into conflict almost inevitably, and that creates employment for critics. Since critics disagree, we get *metacritics,* critics of criticism. Metacritics tend to be philosophers who are interested in the grounds of aesthetic judgment. Thus, the art situation in complex cultures becomes increasingly theoretical, which is what we would expect. The concept of quality does not disappear, but in the process of definition and redefinition, it becomes highly attenuated. That is, it becomes very, very thin.

[2] Here we might consider Friedlander's mischievous observation: "There has been only one art connoisseur who never made himself ridiculous, and he was dumb and could not write." (Max Friedlander, *op. cit.,* p. 35.)

Question three: *Can we teach art, make art, or collect art without a concept of quality?* Well, art students need teachers, and teachers operate (usually) on the assumption that they possess skills their students want to acquire. Or, students think teachers can assist them at the birth of their genius. So, even when studio instruction is very permissive, it assumes there are "good ways" to choose materials, use tools, and employ techniques. Those "good ways" add up to standards of quality which students assimilate *even if* they resist their instruction. There is no getting away from what we were taught when we were young: we fight it or build on it for the rest of our lives.

What about quality in the teaching of art history and criticism? The issue comes into focus when instructors have to choose works for study; their selections are often made for reasons of excellence—but not always. Other criteria are used, such as technical and stylistic innovation, historical significance, or cultural, ethnic, and gender representativeness. In school teaching, the age, background, and psychological development of pupils is as important as quality when deciding what to study. The art *disciplines* also exert their influence, an influence that is often weighted in favor of traditional "touchstones" of excellence.

Obviously, the works chosen for inclusion in school curricula or in college courses of study represent *value* decisions. The question is whether quality is prominent among the values considered. School pupils tend to believe it is. College students, being sensitive to the educational climate, may suspect that political or ideological considerations influence their instructors' choices. But perhaps their instructor merely wish to experiment with new ideas about what quality is.

In the long run, I think curricular choices are made on the following grounds: (1) pedagogical momentum (what the teacher was taught), (2) disciplinary inertia (the canonical list), (3) availability of slides and reproductions (funds for supplies), (4) relevance to student concerns (fear of rebellion), (5) personal preference (enlightened taste), (6) judgments of quality (this takes time), and (7) professional experience (the teacher's determination to survive).

Clearly, quality is low on this list of criteria. But before condemning the hapless teacher of art, consider that he or she must think about quality in terms of a complete course of study and how it influences student perceptions of the kinds and purposes of art, plus a number of other things. Those "other things" include sustaining an interest in art when the course is finished, and, perhaps, building curiosity about the conditions that promote excellence.

When it comes to *making* art, it is clear that notions of quality are instilled very early. As mentioned above, acquiring technique implies learning to do things well. Once learned, technical standards of quality are difficult to violate. Stated differently, it is hard for a good soprano to sing off-key. However, aesthetic quality is a matter of "what" as well as "how." In art as in ethics, means and ends come in the same package. Unfortunately, artists and art instructors are quite capable of concentrating on form while ignoring content. As a result, we see a great deal of technical ingenuity devoted to the expression of trite ideas, trivial ideas, and even vicious ideas.

The separation of form and content poses what amounts to an ethical problem for critics. Here we have to be dogmatic: critics should not judge form as if it exists in a vacuum; they must never say of a work that its form is good while its content is bad, or that content doesn't matter when making critical judgments. Hauser is unequivocal about this: "There are no works of art which are either pure form or pure content."[3] Indeed, a split between the "what" and the "how" is a sign of aesthetic failure; it means that the artist has not completely examined his work. Critics, however, should not walk away from the job: by refusing to sanction the separation of means and meaning we can strike a blow for quality in the best sense of the word.

Certainly collectors care about quality. After all, they invest money in their tastes; and money, in our culture, is a reliable index of personal concern. Collectors may start out by acquiring art related to their lives—their work, travels, decorative needs, and sentimental associations. But, eventually, they pass beyond the memento and souvenir-collecting stage. At first they care about where an object came from, or what it cost, or whether it is rare or one-of-a-kind. Then, after living with an object, they begin to wonder whether it is any good—"good" in an honorific sense.

Thus begins the collector's "itch": he or she wants to possess good things, then good things of a certain type, and finally a *set* of good things. When the collector possesses a *complete set,* each item becomes an exemplar of quality. There is no mystery in the process: the collector discovers that the quality of what he or she owns depends on the operation of the Gestalt principle: the whole is greater than the sum of its parts. That is, the parts derive their meaning and value from the perceived completeness of the whole.

[3] Arnold Hauser, *The Sociology of Art* (Chicago: The University of Chicago Press, 1982), p. 319.

There are other dividends: a collection is prima facie evidence of knowledge and taste supported by the necessary funds (which represent a reward for excellence in another field of endeavor). A collection also proves that the collector has seen many works of art, has recognized the good ones, and has chosen to acquire those which are best. The concept of quality permeates every part of the process.

Question four: *Is quality a weapon used to deny the value of the art created by people who lack power and influence?* This is the well-known charge of ethnocentrism combined with a political accusation—namely, that quality judgments are instruments of oppression. I fear the charge of ethnocentrism is often justified—not because we are mean-spirited, but because of the tendency of all peoples to prefer what they know best. As for the political accusation, I believe it is largely unwarranted.

The substance of the political charge is that quality judgments have little or no relation to artistic excellence; presumably, such judgments reflect the prestige or cultural status of the people from whom the artist sprang. Thus, Polykleitos, a Greek sculptor of the 5th century B.C., is considered a great master because of our high regard for the Greeks as founders of the Western tradition in philosophy and politics. This argument may seemed plausible, but it is seriously flawed.

First, Greek art owes much to the art of Egypt and the ancient Middle East. In other words, the Western art tradition rests on an African and an "oriental," or West Asian, foundation; so there is plenty of prestige to go around. Second, the Greeks were conquered by the Romans, who nevertheless "looked up" to the Greeks as artists, teachers, and thinkers—which means that a powerless people enjoyed a great deal of respect in the ancient world. Why? They enjoyed respect because of the *quality* of their best work, which was created by artists like Polykleitos.

We can argue about the social, political, and geographic causes of Hellenic creativity. The "wily Greeks," as Homer called them, learned and borrowed from many sources. (They also knew what *not* to borrow.) What we should avoid is ascribing the greatness of classical Greek art to the prestige of Greek culture; that puts the cart before the horse. The high reputation of Greek culture is due to the excellence of specific monuments of Greek architecture, painting, and sculpture.

The political charge against the concept of quality makes a logical error: it confuses an effect with a cause. Art is the cause and reputation is the effect. Why does English cuisine have a mediocre

reputation? Because French, Italian, and Chinese cooks prepare better dishes. Critical judgments, as I understand them, are not judgments of artists or their race, creed, and class; they are judgments of "good cooking," or *quality*. And, quality, as we have said, exists *in* the work: it has an *objective* existence.

For critics, the objective existence of quality is crucial. If quality does not exist in the work, then it has to be derived from the artist's race or gender or nationality. Then the locus of value is shifted away from art and toward some other category or discipline—genetics, politics, economics, or demography. Naturally, that makes us unhappy; we thought art was the center of our critical discussion.

Now to the issue raised at the beginning of this chapter: Is a sense of quality "innate, inherited, determined by one's culture?" Is our taste "fixed in advance of judgment?" The answer is "yes," if we don't think about what we are doing. But it would be "no," if we pay attention to the visual facts and reflect upon our received ideas. The study of art criticism is designed to do just that: to enable viewers to make independent judgments. Under the aegis of criticism we are free to make up our own minds.

THE RUMBLE OVER MULTICULTURALISM

Multiculturalism has generated more heated debates and more polemical writing than anything since the emergence of the op-ed page and the television talk show.[4] The literature on the subject has grown to immense proportions if only because of its potential impact on education, politics, economics, sociology, and art. To do justice to the literature of art and multiculturalism alone would be a daunting task. Here we shall focus on a narrow part of the subject: multiculturalism as it affects practical criticism.

But first some definitions and premises are in order. *Culture* is the totality of what we have learned; it includes all the beliefs, values, attitudes, habits, and customs shared by a people. Usually, a culture characterizes people who are related by language, art, religion, kin-

[4] The funniest prose I have read on this subject comes, naturally, from Russell Baker, who would have made a great art critic: "But the question, you see, is centrified on the monodynamical ethnicity inherent in the victimification of the bisexualized Eurogendering embedded in the traditionalization of the curriculumized decalcomania." (Russell Baker, "Scipio, to Hannibal," *The New York Times*, June 25, 1991.)

ship, nationality, occupation, class, or education—and, of course, food preference.

Everyone belongs to a culture of some sort, everyone "has" culture, and no one is "culturally deprived." This latter expression is a code word for the attitudes and practices of people who are considered "disadvantaged," which is a code word for people whose culture is "dysfunctional," which is a code word for societies, institutions, and lives that are breaking down. Because anthropologists and ethnologists study all these phenomena, the culture "game" is replete with code words, euphemisms, and circumlocutions. As with art criticism, the terms gain meaning in context.

What the code words imply (but are too tactful to say) is that cultures are important to their members even when they do not promote their members' prosperity or success. For example, members of rural poverty cultures are often passionately attached to their folkways despite their material deprivations. They may not even know they are deprived. Sometimes, the skills they have developed in coping with deprivation turn out to be "core values" of their culture—values they want to preserve long after their hardships have disappeared.

What the multiculturalists want us to know is that every culture—high or low, rich or poor, "exotic" or mainstream—generates values that are potentially enriching to persons outside that culture. This amounts to a rediscovery of the Latin saying: "Nihil humanum alienum mihi est." (Nothing human is foreign to me.) Genuinely educated persons tend to share this view; they usually display a lively interest in the beliefs and practices of other people: they read, they travel, they listen, and they try to learn. In this connection, Goethe's observation is relevant: "He who does not know a foreign language does not know his own."

As a doctrine or an ideology, multiculturalism can be understood as an attempt to cope with the fact that great nations—like the United States but unlike Japan or Sweden—are made up of many peoples. Formerly, the culture of one people—mainly Anglo-Saxon—dominated America's cultural potpourri. Now there are many cultures which contribute to, build upon, and compete with our old dominant culture. However, "compete with" does not mean "destroy." At its best, multiculturalism asks that we recognize the worth of cultures that were formerly disvalued or ignored; in that sense, it is a democratizing ideology with pluralism as its watchword.

We ought to mention one unattractive feature of multiculturalism: it is the conviction that critics cannot understand, and cannot

like, art created by persons different from themselves. Why? Because (it is alleged) all values and meanings are predetermined by the critic's culture, that all cultures are emotionally *sealed off* from each other, that men cannot understand women, that whites cannot understand blacks, that "straights" cannot understand "gays," and that the powerful cannot understand the weak. Because, as Kipling said, "East is East and West is West and never the twain shall meet."

These beliefs are unfounded. What is especially disturbing about them is the implicit assumption that art criticism is impossible—namely, that a work of art cannot be explained to someone who does not already understand it. In this view, the possibility of communication across the boundaries of sex, class, nationality, and so on, is denied.[5] This makes no sense: our everyday experience provides all sorts of evidence to the contrary. Cultural products, including works of art, regularly transcend differences of sex, class, and ethnicity *because* of the unity of our species and the power of language, including the language of art. Indeed, here we may have stumbled on a good test of aesthetic excellence: quality in a work of art can often be gauged by its capacity to penetrate ethnic barriers and overcome cultural constraints.

What about the specific bearing of multiculturalism on art criticism? First, we are not critics of whole cultures; we are critics of individual works of art. From our standpoint, anything one says about Greek, Aztec, or Kwakiutl culture must be based on evidence derived from close scrutiny of Greek, Aztec, or Kawkiutl works of art. Second, we should be cautious about rash generalizations. Imagine trying to characterize all of African civilization when there are approximately three hundred art-producing cultures on that continent! This leads to our third critical principle: Never bite off more than you can chew. That is, criticize African paintings and sculptures, and let geographers digest the whole continent.

Now to some questions and answers about multiculturalism and how it affects the practice of criticism.

- Is Western culture guilty of excessive pride? Sometimes it is. But as mentioned above, Western culture is an amalgam of many non-Western traditions and techniques. If the West is proud, it is because we have borrowed widely and built well on our borrowings.

[5] In this connection, the president of the American Federation of Teachers asks a practical pedagogical question: "Is it a teacher's job to tell children that they are entitled to only one point of view because of the racial, religious, or ethnic group they come from?" (Albert Shanker, "Multiple Perspectives," *The New York Times,* October 27, 1991.)

- Is the term "primitive" an expression of cultural elitism? Yes, it is, if we think the art of preliterate peoples is inevitably inferior. It is *not* if we think an aborigine bark painting is as good as a Paul Klee—and better than an Andy Warhol.

- Is "progress" a meaningful idea in art criticism? Is the art of Third World peoples retarded? No, these are silly ideas. Art changes, but it doesn't get better. Prehistoric cave painting is very good; twentieth-century Yoruba sculpture is very good.

- Do we need special criteria to evaluate the work of women, Third World, and minority artists? We do not—if our grounds of judgment are valid, they should apply "across the board." Besides, it is condescending to imply that the art of women or Third World peoples cannot be compared to the art of men and First World peoples.

- Do the subcultures of gays, lesbians, women, and ethnic minorities change the practice of art criticism? Not really; do we care about the sexual preferences of Leonardo, Michelangelo, Rosa Bonheur, and David Hockney when judging their art? I hope not.

- How can critics defend against the charge of "Eurocentrism"— that is, applying European notions of purpose and value to the art of non-European peoples? They can do so by letting each work, regardless of origin, "speak" for itself. Critical method does not *dictate* standards: it lets each work declare its aims; it asks each work to say how it wants to be judged.

- When evaluating Eskimo (Inuit) sculpture, do we need local, or Eskimo, standards of value? We only need local standards if we are anthropologists. As judges of artistic quality, we employ *universal* aesthetic standards which, incidentally, are nicely satisfied by Eskimo sculpture.

- Is a Gothic cathedral better than a Persian mosque? I don't think they should be compared. These building types embody basically different conceptions of religious worship. It would be better to compare Persian mosques with Egyptian mosques, or French cathedrals with English cathedrals.

- Can we explain artworks created by persons we do not know? From a phenomenological standpoint, the answer is yes. The purpose of art criticism is to understand the work, not to know the artist who created it. To know the artist, we should arrange an interview or read his or her biography.

- Should pedagogical critics employ works of art as illustrations of cultures? Yes, they should do so, if they want to. But their "illustrations" must be carefully chosen, and their students should realize that other exemplars might tell a different story.
- Does formal analysis foster the agenda of multiculturalism? Yes, it does, when it enables us to see a work through ethnically neutral lenses. But it does not, when it assumes that creating visual form is the only purpose of art.
- Should art criticism promote admiration of the peoples whose work we study? It should not necessarily do this. We can admire Egyptian and Assyrian art without appreciating the head-bashing practices of the ancient Egyptians and Assyrians!
- Can critics suspend their cultural biases and taste prejudices? They can, but it isn't easy; our socialization tends to militate against open-mindedness. However, we can overcome prejudice and extend our range of tastes. Consider your favorite salads and remember when you hated olives, spinach, and broccoli!

All of us—critics or not—grow up in a culture that predisposes us to like what we see regularly and know best. However, preferring the familiar need not take the form of denigrating what is different. For example, I grew up seeing the work of Thomas Eakins but not the work of Albert Pinkham Ryder. They are Americans, to be sure, but their paintings are "worlds apart." They represent almost opposite ideas of artistic quality, yet now I enjoy both artists. There must be a problem here: How can I respond favorably to such different exemplars of excellence? Am I confused? Does the affirmation of one style of art require the negation of all others? Of course not: I am not confused; I am glad.

The fracas over multiculturalism ought to end with a commitment to ecumenicism and excellence *at the same time.* That should also contribute to a general spirit of humanism. We don't wish to see humanistic studies degenerate into academic turf wars and cynical grabs for political power.[6] If cultural pride served imperialistic pur-

[6] A professor at Harvard diagnoses the situation as follows: "How did we come to appraise works of cultural criticism in terms more appropriate to combat?...We fell into what I call academic autism: close your eyes tight, recite the mantra of race-class-gender, and social problems will disappear." (Henry Louis Gates, Jr., "Opening Academia Without Closing It Down," *The New York Times,* December 9, 1990.)

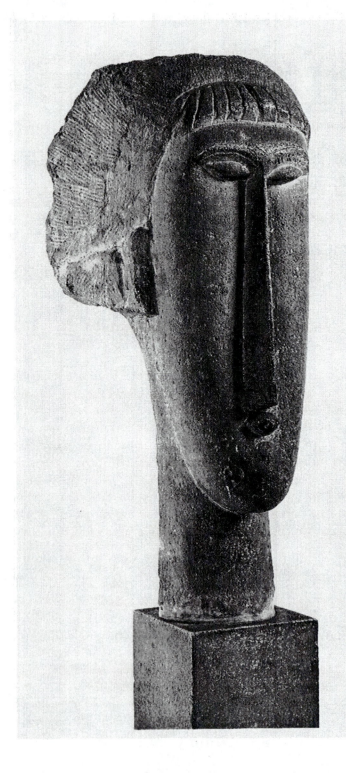

AMEDEO MODIGLIANI, *Head of a Woman,* c. 1910. Limestone, 25 3/4" x 7 1/2" x 9 3/4". National Gallery of Art, Washington, D.C. Chester Dale Collection.

Could this be a West African carving? Stylistically, it resembles Ibibio work, but physically, the face looks Japanese. In fact, Modigliani was an Italian Jew who lived and worked in Paris. As for Chester Dale, who acquired the piece and gave it to the National Gallery, he was a very successful American financier who knew quality when he saw it. What we have, then, is a prime example of multiculturism, from the creation to the collection to the experience of art.

poses in the past, that proves my point: the goal of criticism ought to be aesthetic understanding, not cultural hegemony, not dominion over others.

When an artifact has cross-cultural appeal—as with Levi's jeans and American sitcoms—our common humanity is reasserted. If French cuisine prevails in the best San Francisco restaurants, that does everyone credit. Critics of food, fun, and art must not succumb to cultural chauvinism. Thus, we hope that Big Macs continue to prosper in Moscow, and that Disney World thrives in Paris, as Seurat's *Grand Jatte* is celebrated in Chicago. No one will get hurt, some will be nourished, and many will be enriched.

THE PROBLEM OF PORNOGRAPHY

For an art critic, pornography is just another art genre, like landscape painting, portrait sculpture, or poster design. However, the term is loaded with sexual meaning, which makes it a matter of controversy almost as soon as it is mentioned. Indeed, *pornography* is almost a "fighting" word: some will fight for the right to create it, some for the right to display it, some for the right to see it, and others for the right to suppress it.

But what is it? Before entering the fray we need some definitions. *Pornography* comes from a Greek word meaning harlot's art; presumably, it refers to the graffiti used by ancient prostitutes to attract customers. But while pornographic art may be designed to arouse sexual desire, it need not be *obscene*—that is dirty, disgusting, or repulsive. For some people, pornography is another word for *erotic* art—art that depicts, refers to, or reminds us of, sexual acts. For others, pornography designates sexual violence (especially when it is directed against women and children).

By a stretch of the imagination, any representation of the nude and any depiction of love can be considered erotic. To the extent that such depictions hint at, or look forward to, physical acts of love, they may be considered pornographic. And if this pornography is bad enough (prurient, lascivious, morally offensive),it is deemed obscene. Then the law enters the scene. Why? The obvious reasons are that someone's human rights might be infringed, immature persons might be harmed, and practices dangerous to the health or safety of the community might be promoted.

AMEDEO MODIGLIANI, *Nude on a Blue Cushion*, 1917. Canvas, 15 3/4" x 39 3/4". National Gallery of Art, Washington, D.C., Chester Dale Collection. Can this be a pornographic work? Surely it is erotic. It may also come across as somewhat cloying. Is there a certain too-muchness about the model's communication of her sexuality? Well, we are not in the "good taste" business; our task is to account for the aesthetic factors that cause our reactions. Others can decide whether the painting is a celebration of the female form, a carnal invitation, or a salacious suggestion. Could it be all three?

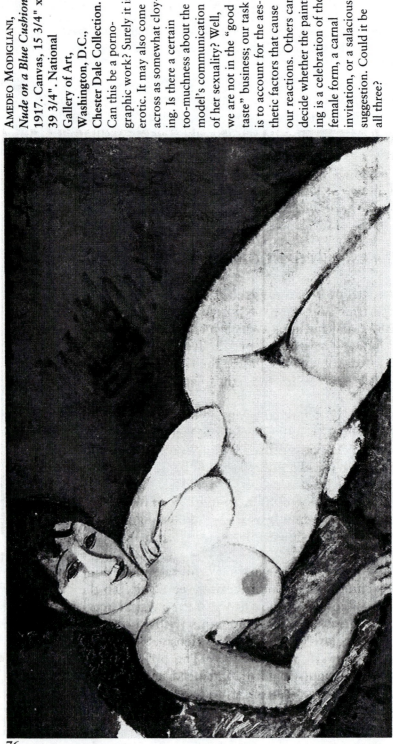

Notice the word "might." Legal and other authorities must often engage in prediction: they must decide whether certain works of art will *lead to* certain behaviors. Then they have to decide whether those behaviors threaten the peaceful life of the community. In other words, they must act as art censors. Not surprisingly, policemen, sheriffs, and constables have trouble with the subject of pornography: it is not a normal part of their training; it asks them to anticipate the behavioral consequences of aesthetic effects.[7]

In addition to legal authorities, lay persons may feel called upon to act as censors—whether of "hard porn" or "soft porn." Often, they are people who believe passionately in the capacity of art to educate. That is, they believe art's purpose is to guide, exemplify, and elevate; and, because art is *the* great educator, they are determined that it shall educate well, or at least do no harm. This point of view echoes Plato's moralistic position; he maintained that artists should be excluded from any well-governed state. However, they *might* be admitted if they created socially constructive and spiritually uplifting works of art.

Who decides whether a work of art meets Plato's criteria? Plato thought philosopher-kings, the governors of his ideal republic, would be the best judges. Today we have no philosopher-kings, but some members of the clergy—sure of their morals and confident in their sexual tastes—feel they are well qualified to judge pornography. Artists also consider themselves good judges of pornography—porn as "art"—and this principle is embodied in the institutional practice of "peer review." As for lay censors, they may not know whether Plato's standards have been satisfied, but they think they know when his standards have been violated.

What about art critics? First, art critics do not censor. We do not decide which works shall be displayed on the grounds of their moral or erotic content. Indeed, we have no control over what is exhibited in galleries and museums. However, when the critic is a teacher, he or she decides what to show and discuss, and no one doubts this decision is part of his or her professional responsibility. And, when the critic is a journalist, he or she may choose not to write about certain works, and no one questions his or her "news judgment." When the critic is

[7] It is the intervention of legal authority that frightens many artists and critics: "Once we allow lawmakers to become art critics, we take the first step into the world of Ayatollah Khomeini...". (Robert Brustein, "Don't Punish the Arts," *The New York Times*, June 23, 1989.)

an artist, he or she may repress sexual material in the light of what he or she thinks the public can take or understand; and no one questions this "poetic license." Do these decisions constitute censorship or prior restraint? Perhaps; I mention them lest we think only prudes and puritans censor what the public sees.

If critics will not censor, how can they fulfill their moral obligations to the public?[8] Some would argue that critics have no moral obligations to the public; they only have *aesthetic* responsibilities. But that sounds like an evasion; it restates the familiar opinion that form and content are and ought to be separate. Art history, however, suggests that moral and aesthetic values converge; we cannot deny that works of art have consequences—political, economic, and behavioral consequences—which will be judged on moral grounds whether we like it or not.

This brings us back to the practice of art criticism. What must we do—as critics but not as censors—to fulfill our moral obligations to the public? Consider this answer: When a work of art presents itself for criticism, or if we choose it for critical commentary, we must interpret it honestly and explain it completely to the public as best we understand the work and as best we know the public.

By *honest interpretation*, we mean what the dictionary says: "without fraud." Critics are professionally obliged to identify forms by their right names, to describe their actions truly, and to interpret their meanings candidly. Alas, some critics describe represented actions as arrangements of light and dark, or as textural variations, or as thrusts and counterthrusts in an overall pattern of pictorial design. This is obviously a false form of aestheticism: it reduces meaningful imagery to meaningless decoration; it pretends to rise above mere iconography; and it violates our principle of the unity of form and content. Worst of all, it involves a denial of meaning or a suppression of meaning, which is the whole purpose of criticism.

By *complete explanation*, we mean placing an artwork in its full and right context. In the case of a pornographic work, the critic should explain it according to the way it asks to be explained: as a how-to-do-it diagram, as an arousal device, as an advertisement for an unrelated product, as an ideological statement, as an attack on bour-

[8] Saying we are dead-set against censorship is risk-free and frequently self-righteous. Consider this point by a well-known liberal scholar: "Just because one opposes censorship, one need not be seen as agreeing with pornographers." (Gary Wills, "In Praise of Censure," *Time*, July 31, 1989.)

geois taste, as a means of provoking censorship, as a glorification of pain or torture, as a celebration of erotic pleasure, as the announcement of a new sexual technique, or as plain "showing off."

From this incomplete list, it is plain that pornographic art ranges widely in meaning and purpose. Surely some of its meanings are repugnant. But that cannot be known in advance. Suppose, however, that a work is so repulsive that the critic cannot give it the benefit of a thorough analysis. Then so be it. There is no law requiring us to undergo pain in order to perform as critics. Of course, if we *recuse* ourselves, as the lawyers say, we cannot understand the work, and hence we forego the right to explain it.

The point of this discussion is that we are free to dislike pornography, but it is not our function as critics to restrict or censor it. On the contrary, we should make its meanings as clear and explicit as we can. This is a prudent policy, I believe, since the public will encounter pornography in any case, so it might as well know what this art is about. As for our moral obligations, they are best served by providing the public with the necessary tools—critical facts, critical reasons, and cultural contexts. Then, armed with the right weapons, people can inform their sensibilities and make up their own minds.

REFERENCES

Angus, Sylvia. "It's Pretty, But is it Art?" *Saturday Review,* September 2, 1967.

Brenson, Michael. "Is 'Quality' An Idea Whose Time Has Gone?" *The New York Times,* July 22, 1990.

Canaday, John. "Esthetics Versus Anthropology in the Art of Africa," *New York Times,* June 16, 1974.

Dorfles, Gillo. *Kitsch: The World of Bad Taste.* New York: Universe Books, 1970.

Downs, Donald A. *The New Politics of Pornography.* Chicago and London: University of Chicago Press, 1989.

Feldman, Edmund B. "Ideological Aesthetics," *Liberal Education,* March/April, 1989.

Friedlander, Max J. *On Art and Connoisseurship.* Oxford: Bruno Cassirer, 1942.

Geertz, Clifford. *The Interpretation of Cultures.* New York: Basic Books, 1973.

Gimpel, René. *Diary of an Art Dealer.* New York: Farrar, Straus and Giroux, 1966.

Glikes, Erwin A., and R. Bruce Rich, "Leave Sexually Oriented Art Alone," *The New York Times,* May 5, 1987.

Glueck, Grace. "Clashing Views Reshape Art History," *The New York Times,* December 20, 1987.

Greene, Theodore M. *The Arts and the Art of Criticism.* Princeton, N.J.: Princeton University Press, 1947.

Hess, Thomas B., and Elizabeth C. Baker (eds.). *Art and Sexual Politics.* New York: Macmillan, 1972.

Hoekema, David A. "Artists, Humanists, and Society," *Art Journal,* Fall 1991.

Holbrook, David (ed.). *The Case Against Pornography.* London: Tom Stacey, 1972.

Jopling, Carol (ed.). *Art and Aesthetics in Primitive Societies.* New York: E.P. Dutton, 1971.

Kramer, Hilton. "Is Art Above the Laws of Decency?" *The New York Times,* July 2, 1989.

Kronenberger, Louis (ed.). *Quality: The Image in the Arts.* New York: Atheneum, 1969.

Lucie-Smith, Edward. *Sexuality in Western Art.* London: Thames and Hudson, 1991.

Murdoch, Iris. *The Fire and the Sun: Why Plato Banished Artists.* New York: Viking Press, 1991.

Peckham, Morse. *Art and Pornography.* New York and London: Basic Books, 1969.

Rawson, Philip, *Erotic Art of the East.* New York: Putnam's, 1968.

Smith, Ralph A. (ed.). *Cultural Literacy in Arts Education.* Urbana and Chicago: University of Illinois Press, 1991.

Smith, Roberta. "It May Be Good But Is It Art?" *The New York Times,* September 4, 1988.

Sparshott, Francis. "Excellence in the Arts." *Journal of Aesthetic Education.* Winter 1986.

Wilkerson, Isabel. "Clashes at Obscenity Trial On What an Eye Really Sees." *The New York Times,* October 3, 1990.

Wills, Gary. "In Praise of Censure," *Time,* July 31, 1989.

EPILOGUE

I have tried to show that art criticism is interesting work, that it is worth doing, and that is enjoyable for collectors, teachers, and lay people as well as critics. As for artists, they may not enjoy criticism, but if they are serious about their work, they want (and deserve) a serious response to what they have created. For that reason, critics should be scrupulous in their ethics, conscientious in their observations, resourceful in their explanations, and thoughtful in their manner of expression.

This may sound like an impossible list of demands. Accordingly, this book proposes a set of procedures—a method—to save us from making egregious errors while helping us to draw on our deepest resources of feeling, knowledge, and experience in the process of doing criticism.

In my opinion, the method set forth in this book generally approximates what good critics do. It may not produce brilliant results every time, but I think it is fair. It gives structure to an often cloudy enterprise, and it is something solid to lean on when you feel

you are drowning. As for my manner of addressing the reader, perhaps it is too light-hearted in places. But I see no reason to be glum about a subject that has given me so much satisfaction in looking at so many kinds of art, in so many places, with so many students, friends, and strangers.

This book represents an attempt to tell, in the most direct and painless way, what I have learned from years of doing art criticism. Having said that, I am sure the reader can build and improve upon what has been written here.

My experience as a university teacher of criticism has convinced me that almost everyone possesses the ability to be a reasonably good (if not great) art critic. For me, teaching criticism means giving students the courage to trust their own perceptions and draw on their own resources when interpreting works of art. How do they get that courage? Aside from a teacher's support, it is from the conviction that their observations are guided by a method which has been thoughtfully considered, tried out in practice, reviewed and revised, and tried out again.

In my case, the conviction that a good critic needs a good method grew out of three personal discoveries. When I began to teach, I found out that "winging it" as I went along was exceedingly stressful. Second, I learned that "flying by the seat of the pants" was critically unreliable as well as unsafe for my passengers. Third, I realized that I needed a doctrine that could be defended when a precocious student asked why I did what I did and said what I said. So, I devised the method described in this book. Having examined that method, perhaps you will agree that it encourages adventure but not foolishness, enthusiasm but not recklessness, and invention but not downright prevarication. I had the notion that a critic could be deliberate and spontaneous at the same time.

In sum, I have tried to make a "game" of criticism—a game that, like tennis, has to be played with a net. A net, a set of procedures, represents the critic's accommodation to the reality of art. And as this book tries to make plain, it's the "net" that makes your serve look good.